IMAGES
of America
WARRENSBURG
MISSOURI

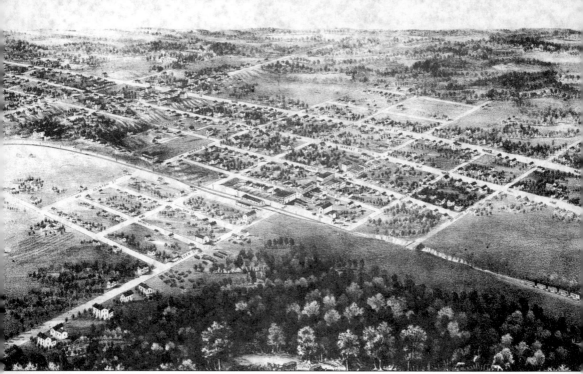

From a balloon, an artist developed this view of Warrensburg in 1869. Warrensburg was already growing to the south and east of the Old Courthouse square. The rail line is clearly visible. Main Street and the Old Courthouse were left behind as a reminder of the early pioneers.

Cover: At the Warrensburg Fair on Holden Street, the number of entrants in this friendly corn exhibition is really quite impressive. All were probably vying for a trip to the state fair, to be a champion producer on the state level as well. This may have been the "Korn Karnival" organized by the Commercial Club.

IMAGES
of America

WARRENSBURG

MISSOURI

Lisa Irle

ARCADIA

Published by Arcadia Publishing,
an imprint of Tempus Publishing, Inc.
3047 N. Lincoln Ave., Suite 410
Chicago, IL 60657

Printed in Great Britain.

Library of Congress Catalog Card Number: 2002110130

For all general information contact Arcadia Publishing at:
Telephone 843-853-2070
Fax 843-853-0044
E-Mail sales@arcadiapublishing.com

For customer service and orders:
Toll-Free 1-888-313-2665

Visit us on the internet at http://www.arcadiapublishing.com

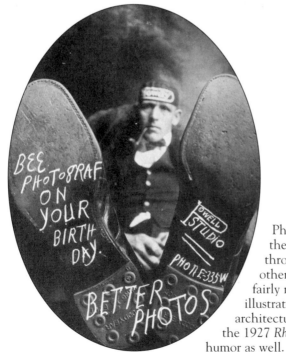

Photographers have effectively chronicled the progress of Warrensburg and its residents through the years. Early photographs have an otherworldly quality to them. Interior views are fairly rare. Many beautiful portraits remain to illustrate the people of the community and its architecture. This advertisement that appeared in the 1927 *Rhetor* shows that these artists had a sense of humor as well.

CONTENTS

ACKNOWLEDGMENTS

The Johnson County Historical Society (JCHS) for permission to use all photos not otherwise noted.

The following publications were invaluable resources:

History of Johnson County, Missouri, Kansas City Historical Co., 1881.
Civil Government and History of Missouri by The Press of E.W. Stephens, Columbia, Missouri, 1897.
History of Johnson County Missouri, by Ewing Cockrell, Historical Publishing Co., Topeka, Kansas, 1918.
Warrensburg, Missouri: A History with Folk Lore, by William E. Crissey, *Daily Star-Journal,* 1924.
Pedaling Through the Past, Wm. C. Tucker, Editor, *Daily Star-Journal,* 1955.
Warrensburg: A Visitor's Study and View by Sue Robinson Crouch, 1974.

Mary Miller Smiser Heritage Library volunteers: Donna Holt, Mary Rainey (research librarian), Jane Reynolds, Jody Iseminger, and friends Lucille Gress and Melva Jones

Flo Mullis, Bessie Carder, Lucille Greer Fette, Elizabeth Smiser Schwensen, Peggy Baldwin, Mary Heberling Bartles and all who have ever contributed photographs.

To my son: Shawn Tyler Kelly, bassoonist and newspaper carrier extraordinaire; Elizabeth Irle; Martha Baile; my brothers and sisters and all our relations.

Proofreaders: Dr. Leslie Anders, Dr. Rose Marie Kinder, and Dr. Bill Foley

Cowley Distributing, Inc. dba/Warrensburg Books & Toys

Editor: Jessica Belle Smith

And all the teachers (and librarians) I've ever had in school, at home, at church, in 4H, in college, in every job that has made me a well-rounded individual, and made this town a memorable place.

INTRODUCTION

Delightful as it has been working on this history of Warrensburg, it has also been a daunting task. Literally thousands of citizens of this community have owned and conducted thriving businesses, served the town as representatives in local, state, and federal offices, taught school at all levels, and helped in every way to build a town that is still flourishing at the advent of the 21st century. Choosing who and what to represent would have been even more difficult if it had not been for the photographs at hand. The selections have been made largely on the merit of the available images. Thanks to the work of photographers, many special events have been recorded. The intent is to present an accurate and well-rounded picture of Warrensburg as it has grown and changed through the years. Please forgive omissions and allow them to be remedied in the future by submitting copies of your family history and pictures to the Johnson County Historical Society. Thanks also to all the teachers. Growing up in a town populated with teachers can really have an impact, if you listen—and learn. If only we understood how soon we should start listening.

Let it also be said that the history contained herein relies largely on the *History of Johnson County, 1881*, Historical Publishing Company. The oral histories collected by this company, while no doubt as accurate as possible, omitted details and added flowery language to the chronicle of our fair city, which has been much quoted and printed as "history." They also charged $5 per listing. Pictures, no doubt, cost slightly more. Other sources, also oft quoted, are listed in the acknowledgments. The time has just passed when we can know the histories even second hand. Court records are the main volumes extant prior to the War Between the States. A few scraps of older newspapers still exist. All the rest has been recorded by the historians who have laid the foundations not only for this work, but also for Warrensburg itself.

Please consider as a caveat this quote from the movie *The Man Who Shot Liberty Valence*. After hearing a revised version of an oft-repeated tale of his heroism from a senior senator played by Jimmy Stewart, the newspaper editor rips up his notes. Stewart's character, Sen. Rance Stoddard, says, "Aren't you going to print that?" The editor answers, "No, sir. This is the west, sir. When the legend becomes fact... print the legend." So, let it not be said that this work is anything but a survey of previous research and reporting, wondrous as that is to behold.

Long live the history of Warrensburg and its many unique residents.

—Lisa (Tompkins Baile Hampton Christopher Lanning Powell, whew, it gets complicated) Irle,
July, 2002

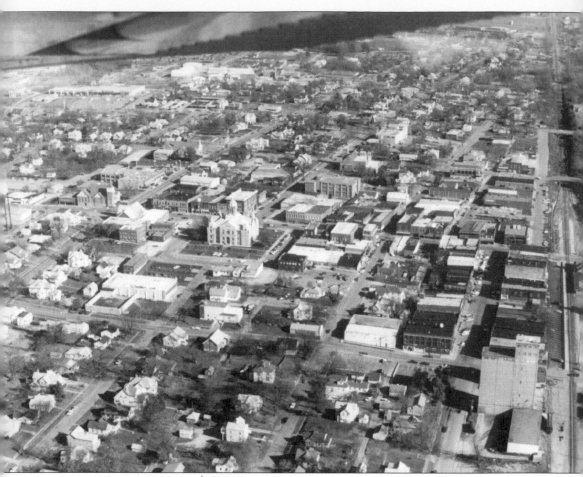

Pictured here is downtown Warrensburg as it appeared around 1992. Freight trains still rumble regularly through town, but the commercial district has again shifted away from the depot and nearer Hwy 50 to the northeast. The downtown is still a professional center. As a result of the cooperation of city officials and local business people, street renovations to improve the appearance and function of Holden and Pine Streets are well underway. (Photo by "Bodie," Mike Bodenhamer.)

One

THE COUNTY SEAT

High atop a hill in what would soon be known as Warrensburg, a site came to the attention of the men who were surveying western boundaries of their new country. One of them was Daniel Morgan Boone, son of the famous frontiersman. Situated between the "Gateway to the West" of St. Louis and a last exit before the "Westport" of Kansas City, the fertile new county of Johnson lay ripe for the picking. Immediately after the Louisiana Purchase, the Missouri Territory was established in 1812 and the State of Missouri in 1821 and plans were laid for the mapping out of counties, townships, sections, and wards. Johnson was separated from a large county called Lafayette in 1834. The first settlers spoke fondly of the remaining native people. Elizabeth F. Grover, daughter of a pioneer, wrote for a local newspaper December 15, 1933, that "The Kaw Indians, related to the Osage Indians, roamed through this country, camped beside the streams and living springs, but, following the custom of other tribes, made no settlements, and gradually retreated westward beyond the Kaw River, when the first white men began to explore the country."

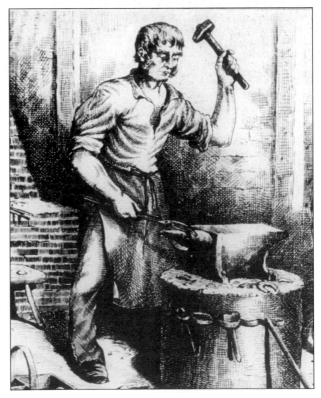

Martin Warren was a Revolutionary War veteran who settled on the "Bee Hunter's Trail," one of the first known trails through the area. He started a blacksmith shop on the corner of what would become Gay St. and College. People from miles around came to have horses shod, tools repaired, and to hear the news of the day. This drawing depicts the man at his trade. In the 1881 *History of Johnson County* he is described as a "plain, old fashioned, conservative farmer and honest man; corpulent in person; without beard; in politics a whig, though he never sought office." James Warren, his brother, is cited as suggesting the town be called Warrensburg. Gay Street has been so named since the earliest days; the reason remains a mystery. It curves around the site where Warren built his first home. (Photo courtesy JCHS.)

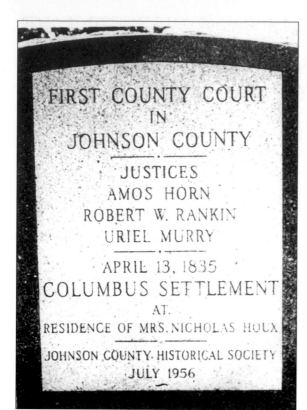

Pleasant Rice and James Houx had followed the "Bee Hunter's Trail" to this spot in the 1820s. In 1836 local officials decided—not without controversy— to move the county seat from Columbus, the oldest settlement in the county, to the more central location of Warrensburg. The tree at Rachel Houx's, under which court had been held since the inception of the county, could no longer accommodate the business of governing the thriving region. This stone commemorates the first county court in the heart of Columbus. The Cumberland Presbyterian Church remains there, an appropriate testament to the first residents.

The town of Warrensburg was laid out and platted by George Tibbs, the county surveyor, in 1836 and was recorded in 1837. Hall Wilkerson's was the first addition in 1837. Benjamin Grover's Depot addition was appended in 1857. Subsequent additions began when N.B. Holden platted three additions, which encompass the property between North and South Streets, and between Holden and Warren Streets in 1858 and 1864. This map, from an 1877 plat book, shows the layout of the original town with a few of the early additions.

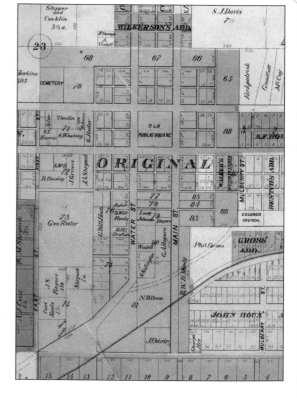

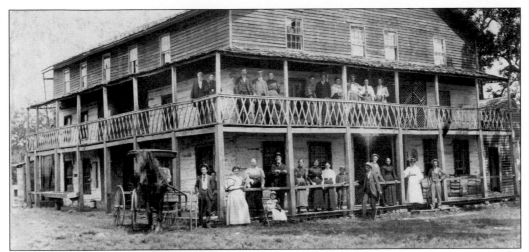

The "First hotel in Warrensburg?" reads the note accompanying this photo. Maybe it was the second or third, as the first was only a small cabin. This building, c. 1840s, may have been used as a hospital in the Civil War. The Bolton House was located near the original square at Main Street at Water and Culton Streets. Other hotels stretched north on Main. The Bolton House was taken by soldiers in 1861. An ad in the *Daily Standard* announces "Closing Sale of Government Property at Warrensburg, Missouri, commencing Monday, September 4th, 1865." There follows a list of all the horses, mules, army wagons, saddles, tents. . . "and all the GOVERNMENT BUILDINGS at Warrensburg, Mo. consisting of the BOLTON HOUSE formerly occupied as District Headquarters, warehouse, stables, and sheds." Several hotels conducted a thriving trade around the old square.

Soon after John Evans opened his store in a "round pole cabin" on Gay Street, W.H. Davis & Company set up shop on the square during the 1830s. The general store provided all the needs of the pioneer. The exact location of this store is unknown. The Davis Store (still standing) was built c. 1869 on the corner of Main and Gay. The store originally had two floors, but the second was removed on the orders of the owner's wife. In its later days (owned by W.O. Davis) it featured a bench in front where an electric wire delivered a small shock to those who tarried there too long. The family staunchly continued, doing business in the original town until the 1960s. The Davis Store is all that remains of the thriving town square that surrounded the Old Courthouse. (Pencil drawing by Katie McNeel, for the 2002 WHS Art Club Calendar.)

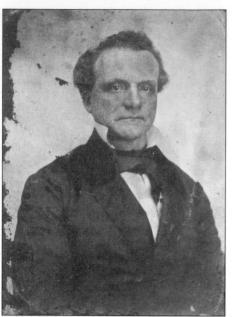

James Douglas Eads (1813–1871), a founding father of Warrensburg, had been a pastor in the Blandensville, Illinois, Christian Church, a physician, an Iowa politician, and a veteran of the War Between the States (Captain in the Missouri State Militia). He was also editor of the *Signal*, a Warrensburg paper predating the Civil War. After the war, he edited the *Warrensburg Journal*, which became today's *Daily Star-Journal*.

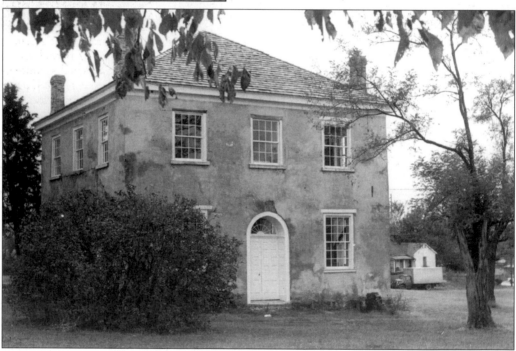

By 1837 the site for Warrensburg's first courthouse had been selected by a committee that included Daniel Morgan Boone. Court records include quantities of material and requirements for a 40-by-40-foot building on the public square at 306 Main Street. The Old Courthouse is now a museum owned by the Johnson County Historical Society and has been restored to its original specifications. The facing was originally a soft brick that was stuccoed to preserve the building. A native sandstone sidewalk with guttering remains in front of the building, another of the tremendous preservations that allow visitors to experience this celebrated property (listed on the National Historic Register) as earlier generations saw it.

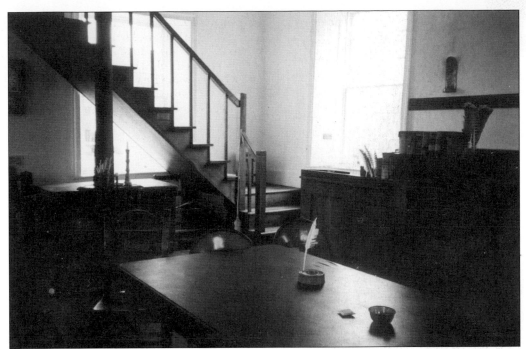

According to the original plans, the restored courtroom features a hand-built judge's bench, period pews from the Fair Oaks church, walnut candle chandeliers, a floor of period square bricks, and a walnut staircase. Clem Clark was the carpenter and many concerned volunteers donated time, furnishings, and money to see that this building, completed in 1842, was preserved for future generations. The tradition of prosecution and defense sitting at one table in Johnson County originated in the time of this courthouse. (Photo by Helen Neal.)

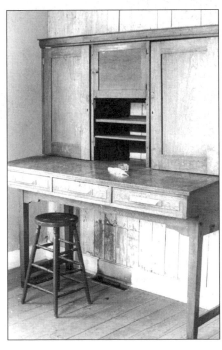

The county clerk and the sheriff, among others, had offices on the second floor resulting in the removal of the interior staircase early on. The judge found the traffic through the courtroom disruptive and ordered the stairs moved outside with a door on the south wall leading to the upper floor. Slaves were sold at public auction from the platform. Early teachers held school in the building.

Believed to be the oldest house in Warrensburg, the Anderson House was built by W.H. Anderson in 1845. Anderson served as county treasurer from 1848 to 1856. The home is now occupied by Arlether Eaves, wife of the late Reverend Melvin G. Eaves, who pastored the Shiloh Baptist church next door for 16 years. On the front step are Mericale Perry and Nate Bennett, her grandchildren, and Zacary Williams, a neighbor. The church can be seen in the background. Originally, the home had two stories but one was removed during renovations. Like most buildings in old town, it was built of a soft brick that has weathered with the passage of time. (Photo by L. Irle.)

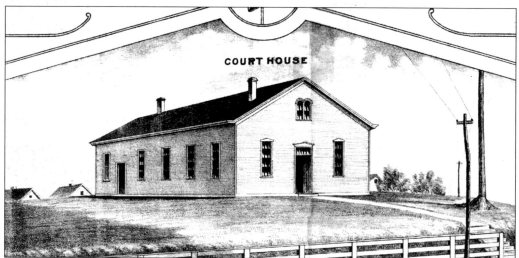

This courthouse, built hastily to move the business of the court "downtown," was not long for the world. Soon after it was built, letters to the editor complained that it looked like a tobacco barn, in no way appropriate for the auspicious beginnings of a "Fourth Class" town. A prank which involved shooting a cannon from a door at one end of the building to an opposite door, resulted in a terrible fire, destroying the building. The plans for the new, more impressive sandstone structure were quickly under way. (JCHS, Plat Book, 1887.)

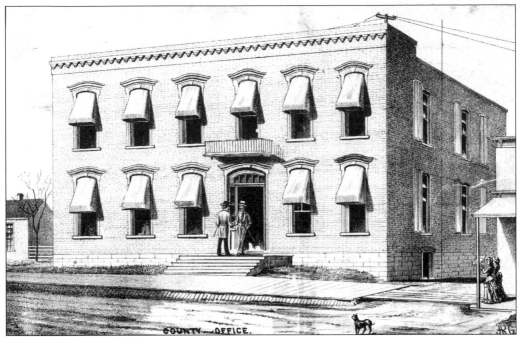

The county offices, housed for a short time in the building shown above, were constructed of brick and stood somewhere near the current square. These buildings were illustrated only in a plat book.

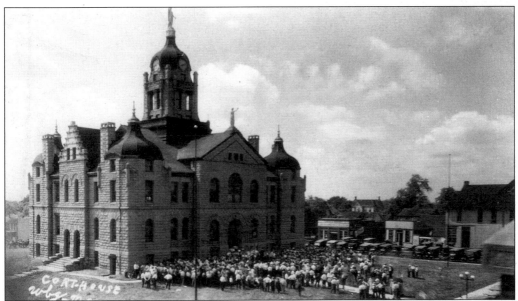

This postcard from the early 20th century shows the third courthouse with the front lawn crowded with people. Far away from the Old Town hill, the halls of justice were temporarily separated from the commercial center at the depot by dirt streets, which served the town adequately until the advent of the automobile. The first court was held here in 1898. Minerva, the goddess of commerce, stands atop, the staff in her hand capped with a ball that was painted gold and, then silver, as the standard for the dollar became controversial. (Photo courtesy Tom Christopher.)

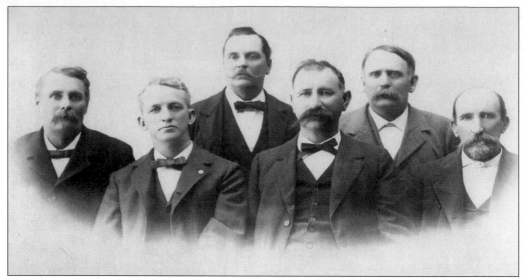

These men all served as sheriff in Johnson County during the years between 1872 and 1904. They include William H.H. Collins, Harvy Russell, Robert Lear, David Baker, and Winfield S. Dunham. The sheriffs had a lot of work to do. As the reconstruction began after the War Between the States, business was good, but there were still outlaws about, and a sheriff who could maintain order was highly valued.

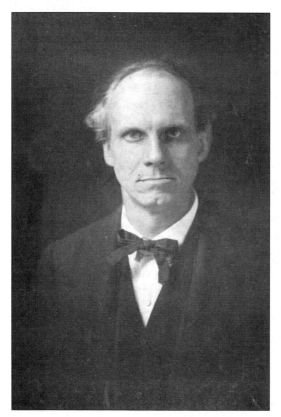

Ewing Cockrell, son of F.M. Cockrell, was an influential man like his father. In 1918 he wrote *The History of Johnson County*. His work drew heavily from the previous 1881 book, but he also recorded the oral histories of many residents. This is his portrait from the 1144-page tome.

In June of 1951, The *Daily Star-Journal* published a contest. An artist had drawn caricatures of some familiar downtown faces. The ones represented here came from businesses close to the square. Contest entrants matched the faces to names below to win.

CONNOR-WAGONER

O.K. RUBBER WELDERS

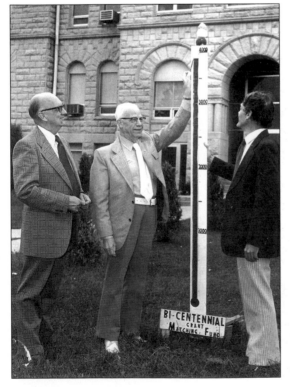

Charlie Clark, owner of Foster's Ready-to-Wear; Dr. A.L. Stevenson, dentist; and Roy Stubbs, curator of the Johnson County Historical Society; check out the progress of their fundraiser in front of the courthouse in 1976. Maintaining the historic structure is still at issue, as the need for space requires moving some functions to the new annex being constructed (at the time of this writing) across the street to the north.

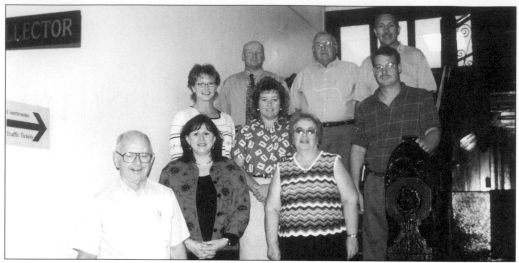

An interior view of the courthouse today shows the stairs leading to the second floor courtroom. The wrought iron stair rail is visible. Pictured from left to right are the 2002 officials: (first row) C.L. Holdren, coroner; (second row) Ruthane Small, collector; Elaine Marsh, public administrator; (third row) Nancy Davis, treasurer; Laurie Mifflin, recorder; Scott Sader, eastern commissioner; (back row) Mark Reynolds, assessor; Bob Banes, western commissioner; Gilbert Powers, county clerk. Not pictured: Ray Fitterling, presiding commissioner; Kay Dolan, auditor; Sam King, surveyor.

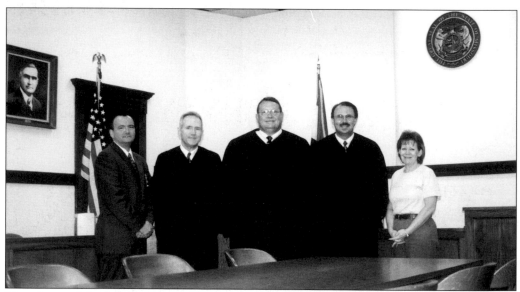

This photo of the Johnson County circuit courtroom pictures the single counsel table that has been used in Johnson County through all its history. The table symbolizes the cooperation that was essential in rebuilding society after the community was divided over the issues of the 1860s. When the move is made to the new annex, the tradition will end. Modern attorneys and courtroom design have prevailed over history, but the spirit of cooperation will continue. Pictured from left to right are Charles M Heiss, sheriff; Garrett R. Crouch, associate circuit judge; Stephen W. Angle, associate circuit judge, Joseph P. Dandurand, circuit judge; Linda Rankin, circuit clerk. Not pictured: Mary Ann Young, prosecutor.

Two

BUILDING COMMUNITY

Incoming pioneers rarely settled far from a population center after Missouri became a state. Wagon trains passed through Warrensburg. Several campgrounds are documented, including one on West Pine Street west of Warren and one at the site of the original round pole store of John Evans. A rowdy saloon business was evident, as were lawyers, land "assayers," hotels, and a few stores. When women and families followed the scouts, churches, libraries, and civic organizations descended on the wild west of Warrensburg like a blanket of snow, covering all the imperfections with a skiff of respectability.

Newspapers were immediately established to provide citizens with information about the political climate, business concerns, and local gossip. One of the first newspapers, the *Gem*, was a handwritten paper posted in the windows of a few bustling stores and passed around town. The *Western Missourian* was the first printed paper before the war. Marsh Foster served as editor. The earliest scrap of newspaper in the care of the historical society is from 1857. The presses were shut down during the Civil War. By 1865, several flourished, and the newest, the *Warrensburg Free Press*, was established in 2002.

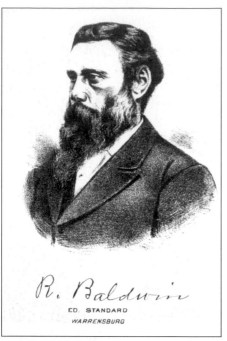

R. Baldwin
ED. STANDARD
WARRENSBURG

Roderick Baldwin was an influential editor of the *Weekly Standard*. Papers were very partisan at the time and rivalry between editors was fierce. Reading the papers of this time is very enlightening as to the concerns of the day. Baldwin was a temperance supporter and was instrumental in establishing a library and in the placement of State Normal #2 in Warrensburg.

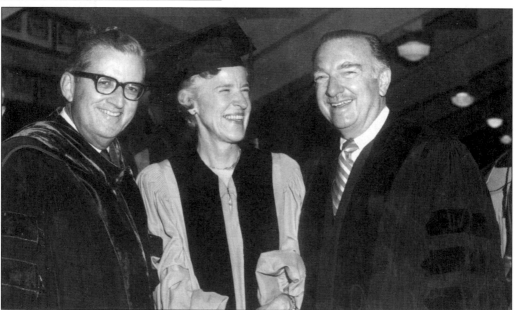

Avis Tucker, the owner, editor, and publisher of the *Daily Star-Journal*—the only daily paper in Warrensburg (an afternoon paper that sometimes scoops the *Kansas City Star*)— has served the community in many ways. Until recently, she also operated 1450 KOKO Radio, as she and her husband, William C. Tucker, the previous editor, have done since purchasing the station in 1958. Shown here with Walter Cronkite, Mrs. Tucker has been honored by the University of Missouri School of Journalism. She has also served as president of the State Historical Society of Missouri and worked in many ways for the betterment of city and state. Several of the photographs in this collection first appeared in the *Star-Journal*. Much of the history of the town has been preserved through her work. (Photo courtesy *Daily Star-Journal*.)

The Reverend James H. Houx was a circuit-riding preacher for the Cumberland Presbyterian Church, which reorganized after the war. Head of a first family of settlers, J.H. Houx has descendants still living in Warrensburg. In 1866 he was arrested, jailed, and fined for preaching without taking the "iron clad oath." Taking the oath would have meant swearing that he had never opposed the Union. It was lying, and he wouldn't do it. Many others felt the same way. The U.S. Supreme Court ruled the oath void in 1870, stating in the opinion that the punishment of Confederates should end. He was a cousin to Isaiah Hanna and mentions of him in the 1881 *History* are frequent. The first church building was Regular Methodist, built by Adam Fickas, four miles north of the city.

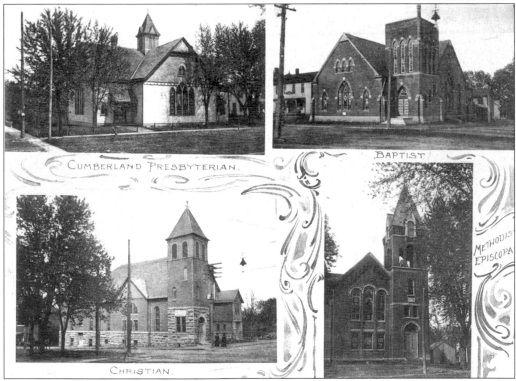

This composite shows the architecture of many of the earliest churches in Warrensburg. In the past few years, the Baptist Church (*c.* 1903) at Gay and Holden and the Catholic Church at Ming and Washington have been razed. Most other churches have experienced remodeling and renovation, as seen from the composite published in a booklet by "C. Harrison, Bookman." Harrison published many postcards during his years in business.

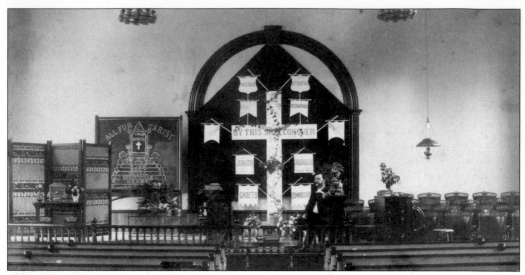

This photo of Children's Day at the Methodist Episcopal Church is a rare look at a church interior of the 19th century, c. 1890. The minister surveys the altar decorated with hanging banners, a recurring theme in church life through many years. The first M.E. Church was started in 1848, but the building was burned in 1862 (intentionally, the early historian William Crissey implies). The importance of the spiritual life of children was well-accepted among the early settlers.

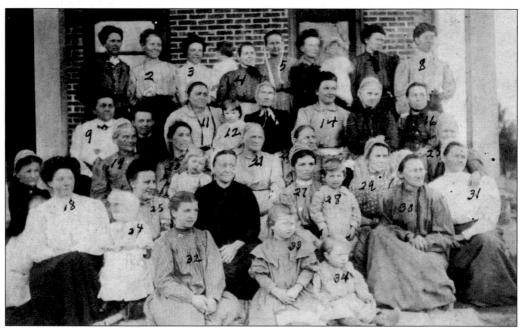

An aid society met at the home of Jennie Neher. Some of the group wear the traditional head coverings of the Church of the Brethren, or "Dunkards," as they were often called. Plain dress, plain living, and pacifism signify the theology of this denomination. This group of women had ties to the Warrensburg congregation. Pictured are Ida Mohler and her daughter Salome (11 and 12) who later married Harold Baile. Salome's two sisters, Ruth and Elizabeth, remained single, taught school, and later volunteered at the JCHS. Exactly what the ladies were aiding is unknown.

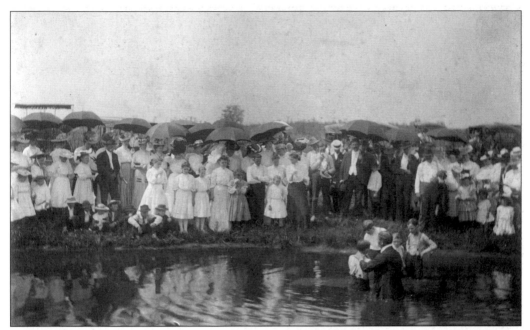

Jessie Osborne was baptized at the Elm Spring Church one Sunday. An outdoor body of water provided the means to be washed clean in rural Johnson County. Jessie was later active in some of the women's clubs. She and her sister Martha were well-known and loved by many.

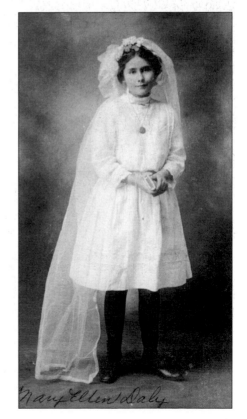

Picture Miss Mary Ellen Daly on the day of her confirmation/catechism in the Sacred Heart Catholic Church. Mary Ellen's family was very devout and she was known to be dismayed when the church removed statues and other icons from the sanctuary in the 1970s. Miss Daly taught elementary school in Warrensburg for many years.

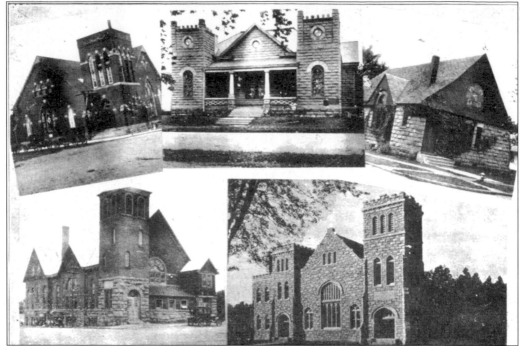

A later composite of churches was published in *Pictures and Prose*, a book proclaiming the virtues of the community to residents and potential newcomers. Some changes are already evident. The First Methodist Church porch has now been converted, but the building is the same, at the northwest corner of Gay and College Streets. The First Presbyterian congregation is now 150 years old.

This group of Sunday school children comes from the First Methodist Church. The students include some well-known residents of today such as June Burr, Tom Cheatham, Mary Carolyn McKinney, Pat Blank, a Clayton child, Janet McMeekin, John McMeekin, and Ann Rogers Delaney. (Photo courtesy Ann Delaney and Connie Heatherly.)

A special gathering was recorded by this photo of the Daughters of 1812. Seated at the far left is Liz Smiser Schwensen. Membership in the club is obtained through careful historical and genealogical research, and limited to true descendants of the specified conflict.

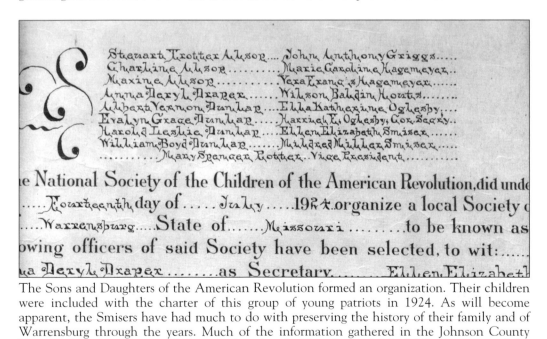

The Sons and Daughters of the American Revolution formed an organization. Their children were included with the charter of this group of young patriots in 1924. As will become apparent, the Smisers have had much to do with preserving the history of their family and of Warrensburg through the years. Much of the information gathered in the Johnson County Historical Society has passed through their hands. They have also faithfully documented the lives of many other residents through their work.

Art Books and Craft Club

Warrensburg Missouri

1919-1920

Organized 1907
Federated 1911

FEBRUARY SIXTEENTH
Economic Problems
Mr. W. E. Morrow

FEBRUARY TWENTY-THIRD
Musicale

MARCH FIRST
Current Topics
Leader Mrs. Stephens
Mrs. Coulter · Mrs. Berkley
Mrs. Shockey Mrs. Collins

MARCH EIGHTH
Address Dr. L. J. Schofield

MARCH FIFTEENTH
What the Women Can Do With the
Ballot in Missouri
Miss Laura Runyan

MARCH TWENTY-SECOND
Some Political Issues
Miss Laura Runyan

MARCH TWENTY-NINTH
New Books Worth While
Mrs. Cheatham
World Power and Evolution,
.......................... (Huntington)
Mrs. Morris

APRIL FIFTH
Current Topics
•Leader Mrs. Montgomery
Mrs. Youngs Mrs. Crossley
Mrs. Anderson Mrs. Clark

APRIL TWELFTH
Address Hon. Wallace Crossley

APRIL NINETEENTH
Art in Its Relation to Public Service
Miss Elizabeth Shannon

APRIL TWENTY-SIXTH
Annual Business Meeting

MAY
Annual Tea

JUNE
Annual Picnic

The A. B. C. Club maintains a Free Library in the Christopher Flats

Many clubs started by women around the turn of the century have provided education and entertainment for their members. A notable example is the Arts, Books, and Crafts club. Their program lists some of the concerns of the day. A versatile club, members chose one of three focus groups upon entering: Homemaking, Books, or Music. Programs offer similar enlightenment for the women to this day.

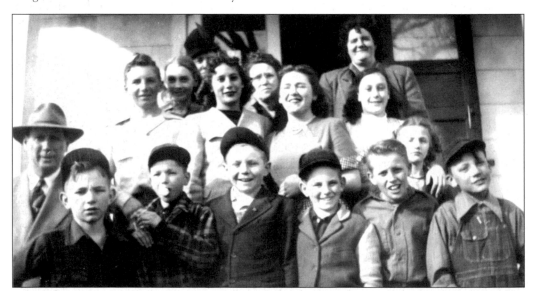

The Teamwork 4H club was located in the country, southeast of the city near Dawson School. 4H, which celebrated its 100th anniversary in 2002, is dedicated to teaching young boys and girls skills that will carry them through their lives. A cooperative system of teaching was employed by parents and project leaders with informational materials distributed by the University of Missouri Extension service. Homemakers clubs were closely associated with 4H. Geographically, both clubs typically centered around a rural school district. A listing of the names reveals their philosophy: Good Neighbors, Honey Creek Hikers, Altogether, and others. Extension has also provided farmers with progressive agricultural information.

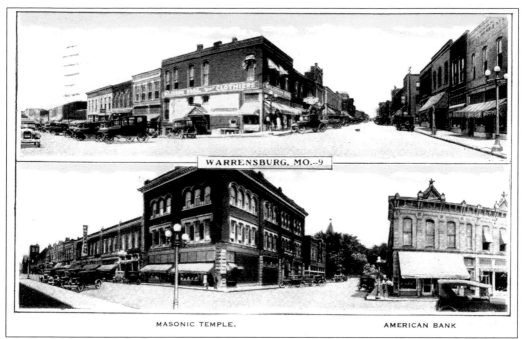

WARRENSBURG, MO.--9

MASONIC TEMPLE. AMERICAN BANK

Pictured on this postcard is the Masonic Temple, an impressive structure, which has recently been refurbished by attorney Bruce Bailey. Many men's organizations have functioned in town as well. A partial listing includes Knights of Pythias, Odd Fellows, Elks, Cryptic Council, and United Workman. Now, Rotary International, Lions, Optimists, and Kiwanis have joined the list. Some clubs also now include female members.

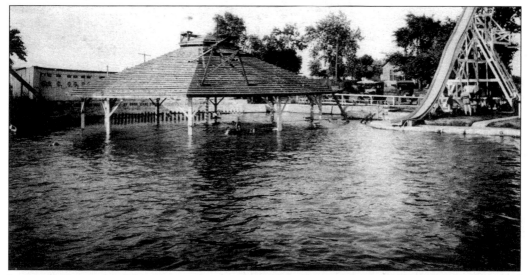

Located just north of downtown, this was an early swimming pool of the community. Called the Hout Natatorium, it was an early manifestation of the importance of public swimming pools. In the 1970s, after a period with only the pool at Garrison Gym on campus, Mr. Alec Nassif began a program to build a new outdoor pool at Grover Park. A new community center has now been built with an indoor pool, exercise equipment, a walking track, and meeting rooms. The senior citizen center is there as well.

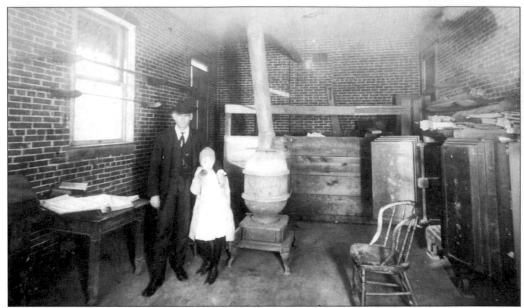

City Hall was located on the north side of the new square at the turn of the century. Pictured is S.P. Tyler, city clerk, and his daughter Thekla who married Mr. Guy Parsons. The family has been involved in the business of the city and county from very early days. A safe, similar to the one pictured, is still used in the office of the current county collector, Ruthane Parsons Small. (Photo courtesy Ruthane Small.)

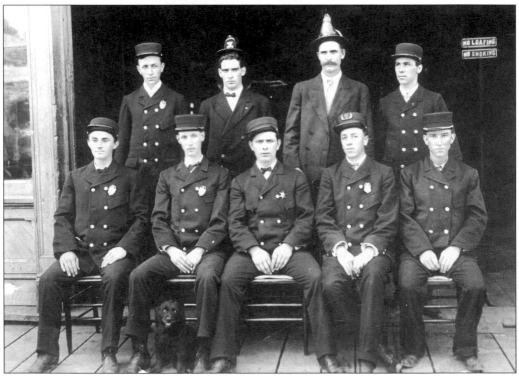

Firemen from the early 20th century are pictured here.

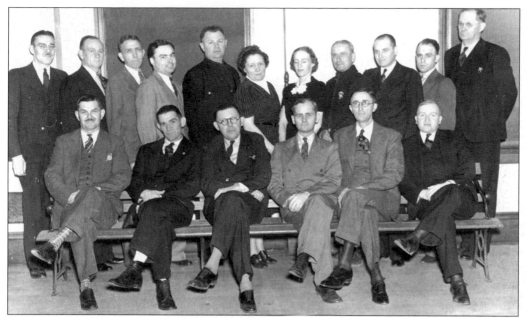

In 1939, city officials had a group photo taken. Among the ranks are Harry Staley, fire chief; Horace Cash, city clerk; Marshall Francis Berkey; R.T. Morton; and Mayor R.M. Shelton. At the time, city hall was located on the courthouse square. A new city hall was built at 102 South Holden where the Martin Hotel used to stand. (Photo courtesy Connie Heatherly.)

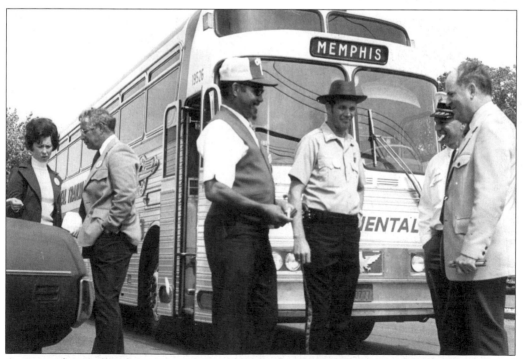

A group of city officials were trying to obtain bus service for the town in the 1970s. Pictured from left to right are Dee Hudson, once mayor and councilwoman, an unknown supporter, the bus driver, Police Chief Gene Burden, Fire Chief Dick Stewart, and Howard Chappel.

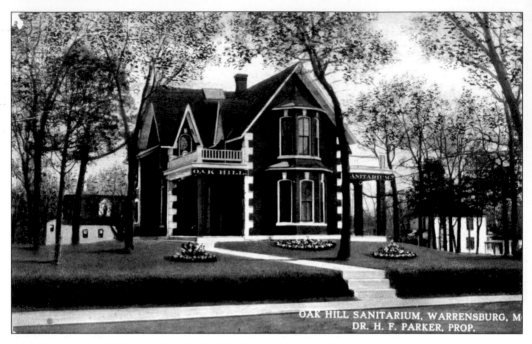

OAK HILL SANITARIUM, WARRENSBURG, M
DR. H. F. PARKER, PROP.

A color postcard depicts the Oak Hill Sanatarium in the early 20th century. It was the beginning of an era, and the community has worked diligently to provide hospital service to residents. A hospital was built on Market Street in the 1950s, and the first licensed general surgeon, Hugh Hanna, returned after his residency. Not too much later, the Johnson County Memorial Hospital was constructed at Gay and Burkharth Road on the east side of town, as pictured below. Stanley Lebow, Len Gregg, Dr. John Price, and John Innes are among the supporters. An expansion at the time of this writing is changing the face of what is now known as the Western Missouri Medical Center yet again.

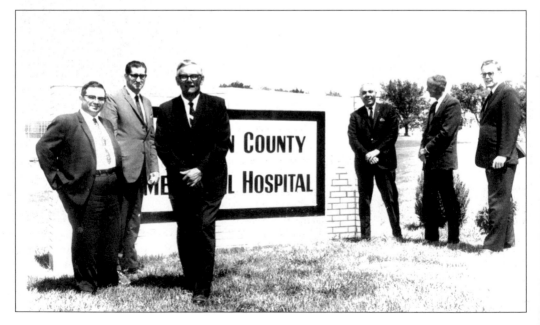

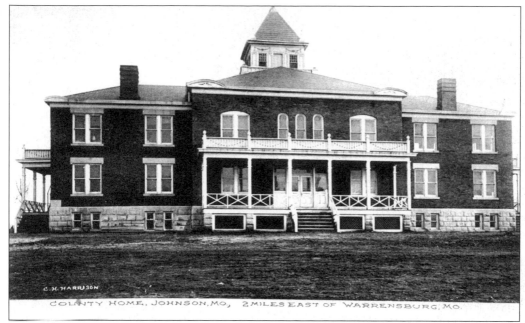

Warrensburg has also provided for the needy. The County Poor Farm was built in 1904 to replace the Poor Farm which had burned west of town. At the poor farm people received room and board for their labors. The building pictured was later known as the Pleasant View Nursing Home, privately run. No longer standing, it was located on the north side of Hwy 50, east of the Stahl Aluminum works.

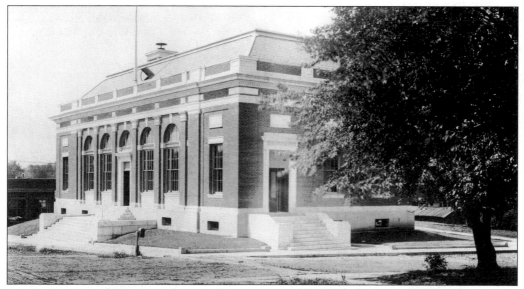

A permanent post office built in the 1920s at a cost of $75,000 represents the ever growing use of the mail by the citizens of Warrensburg. The first postmaster of the community was John Evans—the owner of the first store of the settlement—and the post office was a mobile concern. A series of pigeonholes for sorting moved from business to business, many shopkeepers took a turn for a time in the early days. The current post office, built under Postmaster Robert Theiss in the 1960s, is slated for replacement when federal funds permit.

Enoch Clark Library
OF WARRENSBURG, MO.

18 vols

No. *11* Shelf *9* Value, $ *22.50*

Da 1.25

READ AND OBSERVE THESE RULES:

Only one Book shall be taken out by one person, at one time, which may be retained not longer than two weeks. Provided, always, that any Book may be taken twice by one person, and not more than twice until it shall have been returned to the Library one week.

Any person who shall retain a Book longer than the time prescribed, shall be fined by the Librarian for each volume so retained, 5 cents for each day's retention if the book be a folio or quarto, 3 cents if an octavo, and 2 cents if a duodecimo or smaller Book.

Any person who shall injure or deface a Book, or have it done while in his or her possession, by tearing or turning down the leaves, writing in it, or otherwise, beyond a reasonable wear, may, at the discretion of the Librarian, be fined, not more than the value of the Book.

Any person who shall lose a Book, must immediately replace it, or pay the cost of replacing it.

The first library established in Warrensburg was the Enoch Clark Library, which had ties to the Presbyterian Church. This bookplate was in a book found in the estate of Dr. C.M. and Mary Louise Lederer. The lending rules for the library are clearly spelled out, including the fines. The first library perished in a fire in 1877, but was rebuilt and restocked with insurance money. Faltering after a while, the library closed. It is well documented that early libraries on the frontier were specifically intended to keep young people—and anyone, for that matter—out of the saloons. The reading room of the Good Templars shared this goal. Also it was printed in the 1881 *History* that "the public press of the day... has degenerated into dealing out poison for the youthful mind."

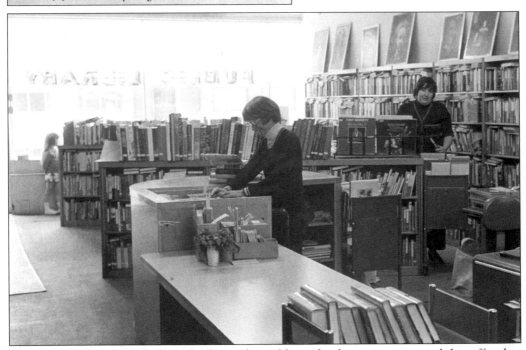

The ABC Club undertook the task of providing a library for the community, and that effort has branched out into the current Trails Regional Library system. This image shows librarians Myra Everts and Betty Stafford at the library when it was located on Market Street. Ye Olde Flower Shoppe has been conducting business there since the 1970s. Trails now operates at the corner of Holden and Culton Streets. The Friends of the Library have been engaged in plans to build a new library, as space is again limiting their growth. (Photo courtesy Anita Ewing and staff at Trails Regional Library.)

Three

MILLS, MULES, & OTHER HARD WORK

A quick check of the map shows that most of Missouri's earliest thriving communities were located along the state's rivers: Lexington, Arrow Rock, Jefferson City. A second wave of settlements grew up along the railroad lines. Fortunate to be on the Missouri Pacific line, Warrensburg was in that second wave. Spur lines like the Rock Island and the MKT were quickly built north and south of the main route, but among the little villages rapidly platted in response, few survive. A rail bed connecting Warrensburg and Marshall was never completed. Warrensburg became a center of commerce, with farmers shipping livestock, merchants stocking the stores for a large surrounding area, and mills grinding grain into flour. Farms were springing up further afield and almost every family had a weekly trip to town for supplies. After that, there was a Saturday night bath and church on Sunday.

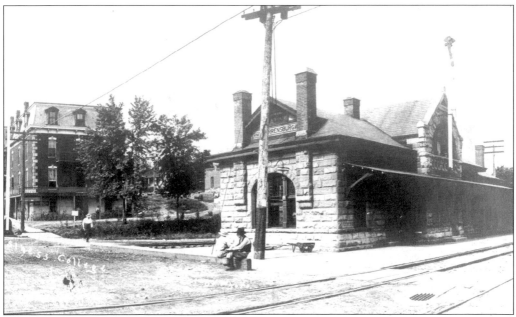

The arrival of the Union Pacific rail line in Warrensburg on Independence Day, 1864, changed the town as few could have imagined at the time. Merchants flocked to the new town on Pine Street to be close to the source of both their supplies and customers, who stopped in Warrensburg on their way west, or sometimes stayed. The early structures were built so hastily that the town took on a "ragged appearance." (*History of Johnson County, 1881.*) The original depot, a frame structure built in 1865, caught fire in 1888. The station pictured was built in 1890. Lizzie Grover reported a living spring at the site of the railroad station before the rail came through.

"Johnson County Corn" reads the note on the back of this photo from the files of the historical society. Agriculture was the main business in town for many years. Other businesses served the needs of the rural population. William Daugherty's, southwest of town, ran during the war though robbed by both sides.

As the hubs of agricultural communities, mills have always been important to the wealth of Warrensburg. Early pioneers used simple hominy blocks, fashioned from the stumps of huge trees to grind their grain, but mills were set up on several creeks as soon as landowners harnessed the power of the water. There were mills on Post Oak, Black Water, Clear Fork, and many other streams. Soon, though, mills were powered by engines and the mechanization of town businesses began. Eureka Mills was one of the first large operations, built in 1867 by Land, Fike & Co. at a cost of $40,000.

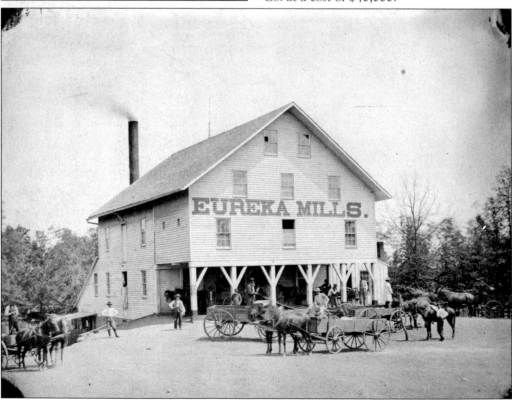

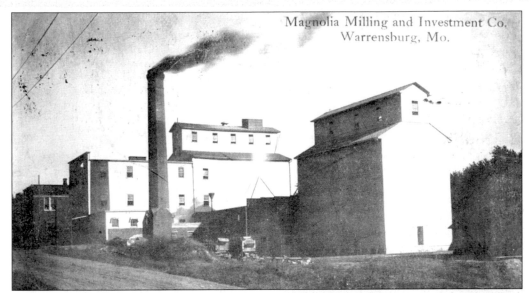

Magnolia Milling and Investment Co.
Warrensburg, Mo.

Magnolia Mills, later Innes Mill, stood on the southwest corner of Washington and West Pine Streets. Owned by Markward and Hartman in 1879, this mill did a booming business. By 1918, it was the only mill in town producing flour: Crystal Brand—the finest flour. Markward, in cooperation with another business partner, Land, also established the Magnolia Opera House on the opposite corner.

This fine looking family of Baldwins came to farm in Warrensburg around 1925. Still on the same property, the family continues in the business. Their farm, and those of many other long-time rural residents of the area, now features a large complex of grain bins and heavy machinery. Several Baldwins live in close proximity to each other on the old homeplace. Pictured, from left to right, are the following: (front row) Willis (father), Ella May (mother), Earl Baldwin, and Glenn Baldwin; (back row) Ruth Kimsey, Homer Baldwin, Mabel Baldwin, Howard Baldwin, and Berniece Matthews. (Photo courtesy Peggy Baldwin.)

Farmers' cooperative shipping associations were another aspect of the agricultural bent of the town. These organizations were helpful, as producers could sell their grain and animals to a central location near the railroad. The business of selling and shipping were then handled by a single concern, leaving more time for farming.

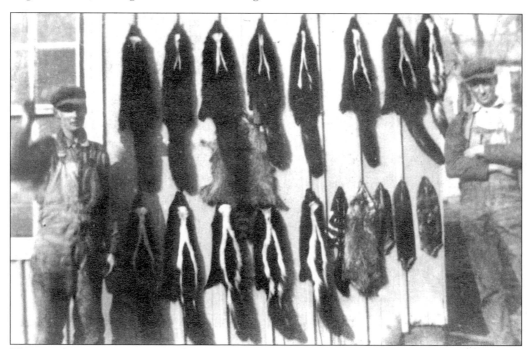

These enterprising young men found out people will buy anything. Clifton II and John Baile, sons of Clifton Augustus and Minnie Hope Christopher Baile, decided to get in on the fur trading business. Skunks are just a little more difficult to trap than a muskrat. The less white on the pelt, the more it was worth. (Photo courtesy Elizabeth Baile Irle.)

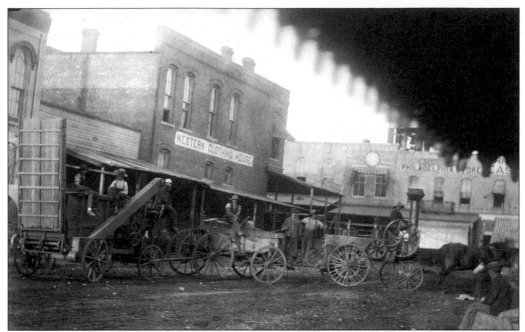

In 1881, Rube Mohler, John A. Adams, Bob Lear, Bob Adams, and Mast Whitley have just unloaded their new threshing machine from the train and are preparing to make the several mile trek south of town to their farm. Modern convenience immediately affected agricultural practices.

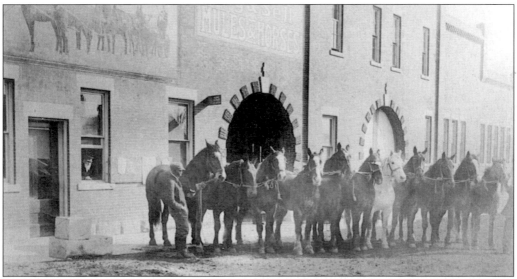

A signature business of Warrensburg, the Jones Brothers operated a Horse and Mule Barn off Railroad Street. An old postcard from those days shows other livery stables up and down the frontage. Warrensburg was considered a real Missouri Mule Capital, thus the sports teams of the University were named. Mules from the area won prizes at the State Fair and at even larger expositions like the one in St. Louis in 1904. The mule barn, known later as Cassinghams and now as True Value Hardware, carried the motto "Through these portals pass the finest mules on earth." Many a country gentlemen tried their hand at breeding fine livestock, some within the current city limits, but others farther afield.

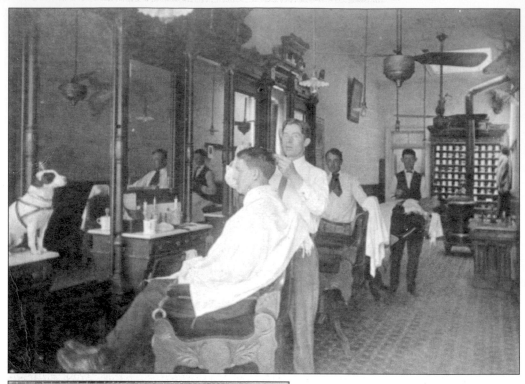

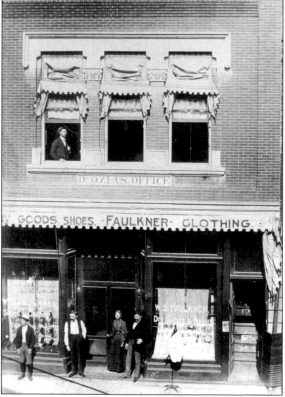

The barber shop was, and still is, a gathering place for men to relax a moment, tend to their hygiene, and share stories about news of the day. This young man gets his locks trimmed as his canine companion looks on.

Doctors set up offices right above businesses, as seen in this photo. All available space was used and easily accessed by the pedestrian public.

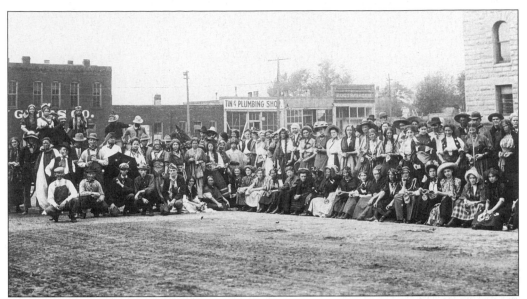

Gypsy Day was an annual college event that brought students downtown. One Gypsy Day event was used as a postcard in front of the Broken Dollar Racket, a sort of general store.

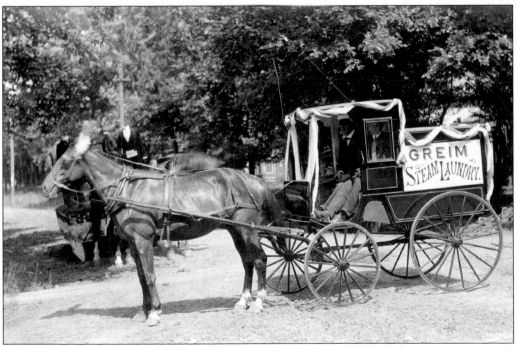

Though not the first steam laundry in town, Greim's was a well-known business, running ads regularly in publications such as fair programs and the newspapers. The whole town has long gotten into the act when the homecoming parade of the college hits town. The Greims were no exception. Greim Harness Shop was located on Holden Street and had a thriving business as long as the town remained a center of livestock production. Horses and oxen were long used as the means to cultivate farm land.

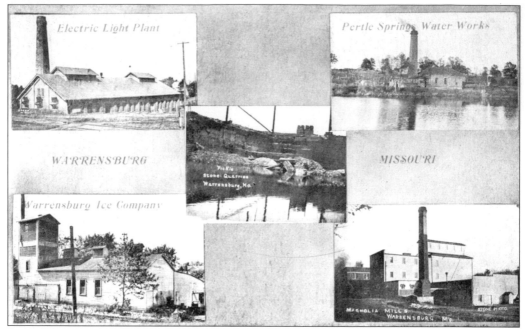

Several businesses that were operating in the early 1900s are pictured here. The industry of the town has always been diverse. At this writing, many of the manufacturing plants that have operated here have closed after buyouts. Swisher Mower & Machine Co. is the exception, family-owned since it was incorporated in 1951.

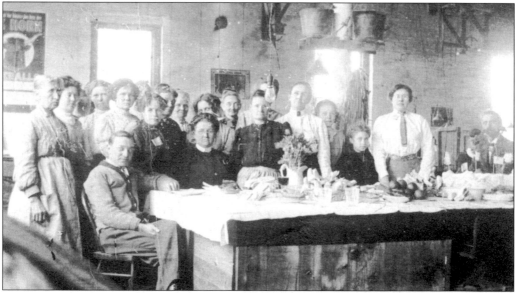

The main existing image of the Lamy Overall Factory is a postcard of a room full of workers sitting at their sewing machines. A little more intimate, this group is obviously sharing a lovely meal at the manufactory. From the beginning, garment manufacturing was a part of the community—Vitt-Mayes Overall, Warrensburg Woolen Mills, Unitog, Unifemme, et al. These establishments have all closed, but a local resident recently started a machine embroidery shop on West Pine, called Gotinu—Unitog spelled backwards!

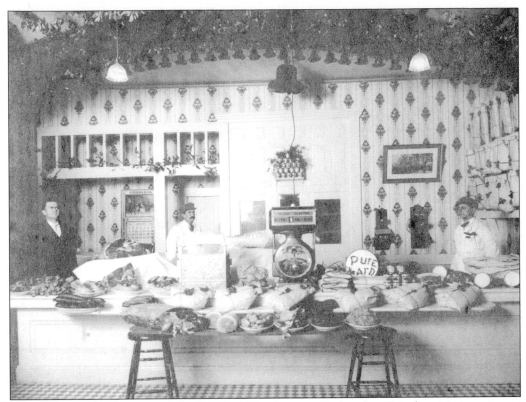

This photograph of a very tidy-looking meat market was likely taken for advertising purposes.

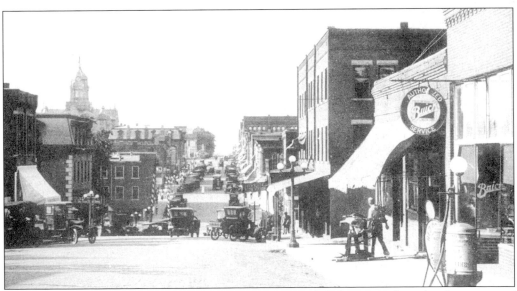

A view north on Holden Street reveals that the automobile has arrived on the dirt streets of the 'burg.

SAY DID YOU KNOW I SOLICIT YOUR PATRONAGE ?

NO USE TO GO FURTHER FOR FIRST CLASS WORK

MORE PEOPLE WANT THEIR WORK DONE FIRST CLASS, EACH DAY DO YOU ?

ABOUT PAINTING, REPAIRING, WOOD-WORK, TRIMMING, SIGNS, ETC.

IT WILL PAY YOU TO GET MY PRICES AND SEE MY WORK

George J. Probst, Proprietor

The Palace CARRIAGE AND AUTOMOBILE Parlors

Warrensburg, Missouri

North-East Corner Square Home Phone 357K

Not to be left behind, Mr. George Probst, who was running the family carriage business, immediately took up the new challenge to provide automobiles to the most progressive of local residents. Clearly, all did not follow the trend at once.

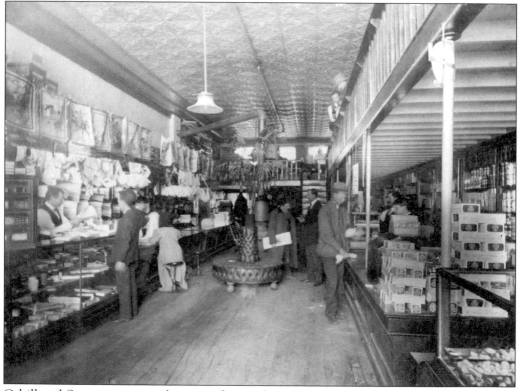

Cahill and Sweeney was another sort of general store that filled many needs of their patrons. Notice the pouffe for seating. The details of daily life gained in photographs are endless.

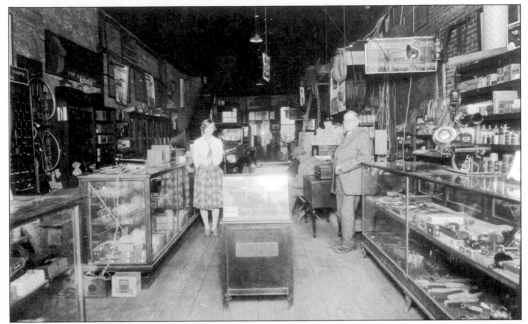

This unidentified store stocks automobiles and phonograph players. The display in the foreground features flashlights. Notice the car behind the people. Lora Tompkins Poe Harrison is on the left. Bicycle tires on the walls, perhaps radio tubes—this shop sells everything modern. There was an electric shop on West Pine; it is possible this could be it.

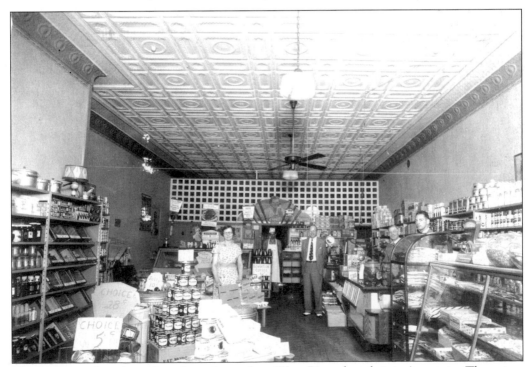

This grocer is thought to have been located on West Pine, though it isn't certain. The prices of the items are clearly marked and the staff looks friendly and helpful.

Sandstone quarries once operated north of town. Railcars full of this fine, blue stone were shipped all over the United States, and some of it was used in state capitals. In Warrensburg basements and retaining walls, the work of these stone masons is evident in the pick and rock saw marks of hand quarried stone. According to Crissey, when the Normal College was to be built in 1872, the quarries were opened. It was remembered that the pillars of the Lexington Courthouse had been obtained here. The St. Louis Chamber of Commerce, encompassing an entire block, was also built of this stone. Another item from the same source states that "for some years the Quarries ceased business, but were again opened in 1922, providing stone for the Normal College Auditorium."

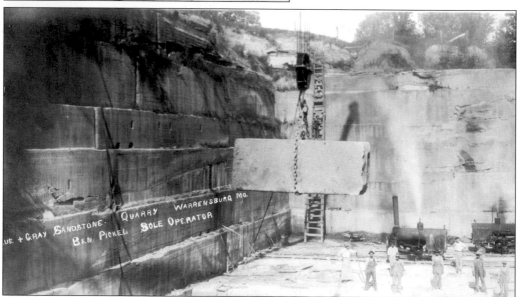

The Pickel Quarry, located north of Warrensburg, produced a very fine quality of sandstone for building and shipped out a trainload a day. The quarry produced such a quantity that a small rail spur was built leading from what is now the 200 block of East Gay to the site off Old 13. Senator F.M. Cockrell owned some of the quarry land at one time. The quarries operating around Warrensburg now work with blasting caps in limestone. Hand quarried stone is a thing of the past.

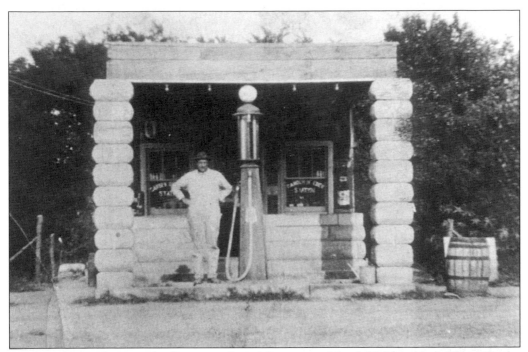

Garden of Eden Station, also known as Pickel Station, on North Holden (then Hwy 13), was made of the famous sandstone. Now on the National Historic Register, in 1951 it was purchased by Charles "Cheese" McBride. According to his wife Eva, he said it paid for itself in only one year. (Photo courtesy Mrs. Eva McBride & Mickey Erisman.)

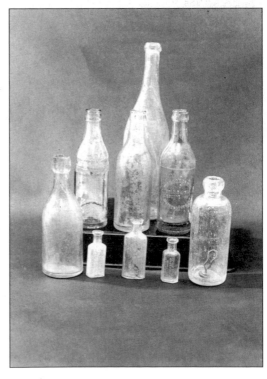

Tom Christopher, a local historian and descendant of the family that developed Pertle Springs, has assembled a collection of bottles that were made in Warrensburg and used for bottling local liquids, from spring water to an assortment of local brews. This photo was taken more than 20 years ago. Christopher says he has found even more examples. One bottle in particular is very rare. Instead of Warrensburg, it says "Warrensbug."

Ads from the 1916 *Rhetor* disclose that only the finest photo plays are shown at the theatres. College students probably flocked to witness the new technology. The talkies were soon to come.

Pictured is the interior view of Citizen's Bank, located at West Pine, southeast corner of the alley. The tellers' cage remained the same for years. The bank was featured on postcards, in Commercial Club (now the Chamber of Commerce) brochures, and is still operating under the name U.S. Bank. Its holding company has changed frequently in the current financial world. One other bank, Peoples Bank of Warrensburg, has become United Missouri Bank (UMB). Some newer banks have come to town, one sharing a name with one of the oldest banks established in the 19th century—The Bank of Warrensburg. (Photo courtesy Liz Schwensen.)

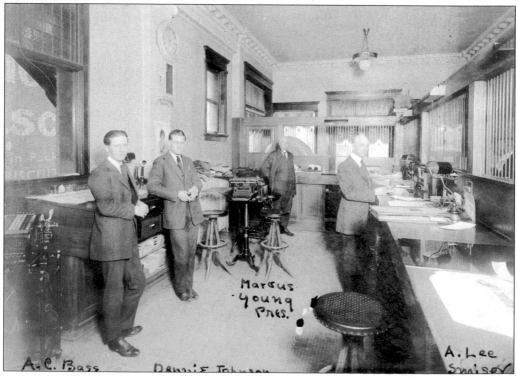

A. C. Bass Dennis Johnson Marcus Young Pres. A. Lee Smison

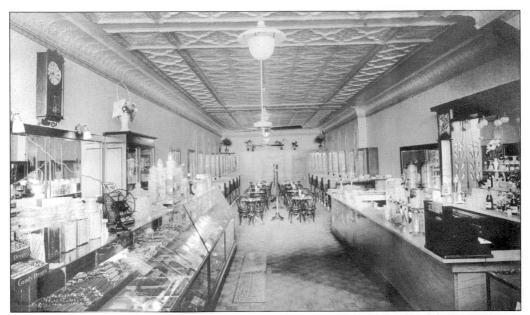

The Candy Kitchen was a well-loved candy store frequented by kids of all ages. Note the fans that have been plugged into light fixtures, if you can keep from looking at the delicious mountains of candy.

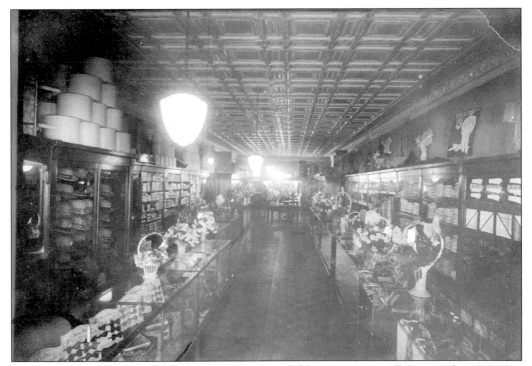

Russell Bros. was an institution in mens' wear on Holden Street just off the courthouse square for many years. Russell's prided itself in making the men of Warrensburg look good. Stocking the finest suits, shirts, and ties left no excuse for shabby dressing. In later days, they rented formal wear. There was a basement showroom as well.

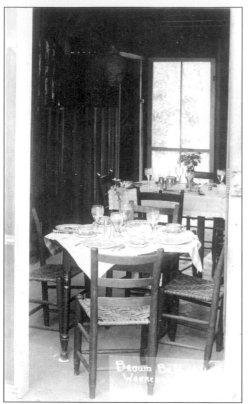

After the automobile changed the way people traveled, the old hotels down by the railroad got some competition. In the 1930s Mary Miller Smiser set up a little house for lodgers. The Brown Betty offered a bed for the night and a light meal. Postcards were made and a brochure created.

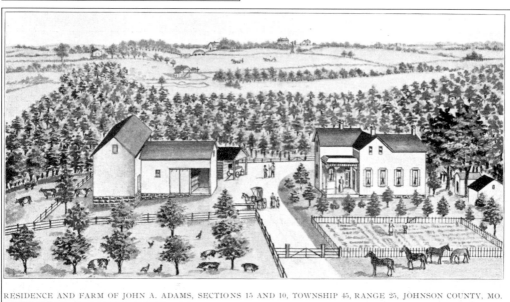

RESIDENCE AND FARM OF JOHN A. ADAMS, SECTIONS 15 AND 10, TOWNSHIP 45, RANGE 25, JOHNSON COUNTY, MO.

The old meets the new at Cedarcroft Bed and Breakfast. Originally set up as a theme B&B in the original 1847 home of John A. Adams, owners Bill and Sandra Wayne have changed with the times. Their new cottage lodging includes beautiful pine furniture, a special turbo tub, and a kitchen to provide for the new demand for separate quarters and fancy amenities. This engraving was printed in the *Portrait and Biographical Record of Johnson and Pettis Counties*, 1895.

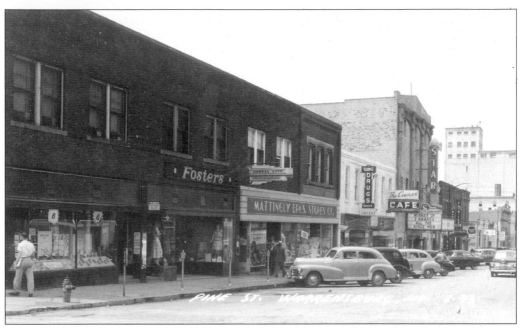

Note these businesses on the south side of West Pine Street: Buente Brothers Drug Store, Fosters Ready-to-Wear, Mattingly's (a "dime store"), Vernaz, and the Star Theatre. Several other institutions of the street are visible as well. The "dollar shop" has replaced the "racket" and "dime store" as the inexpensive place to buy necessities.

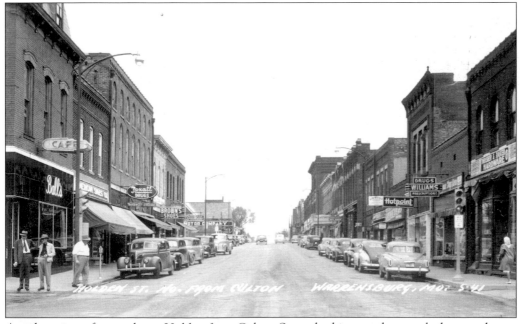

Another view of town shows Holden from Culton Street looking north towards the courthouse square.

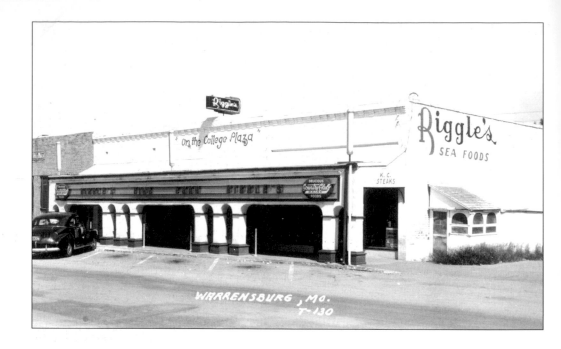

A much-loved site of many fledgling romances, Riggles, in Buente Town on Maguire Street, across from the college, served tasty and affordable meals for many years. Memories of the cafe include the wonderful murals by a local artist that graced the walls. *The Last Supper* painted by Walt Houts, as seen below, was a favorite, printed on business cards by the proprietor. Only one building remains of Buente Town, as it has been usurped by the growing university.

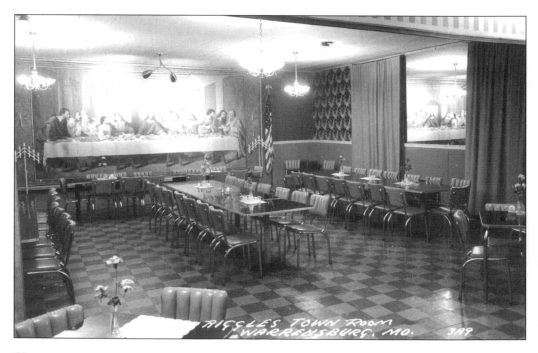

The grand opening of Shively's, a mens' wear shop, brought in a real crowd. Lora Harrison stands behind the counter. Mrs. Shively may be signing people up for a drawing. This building is now the location of Main Street, Inc.

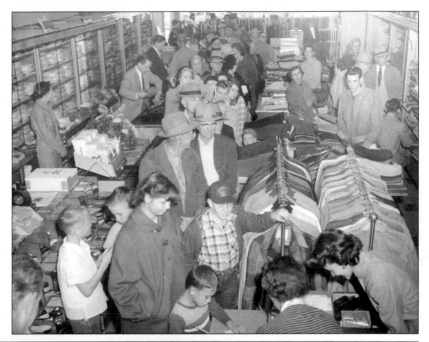

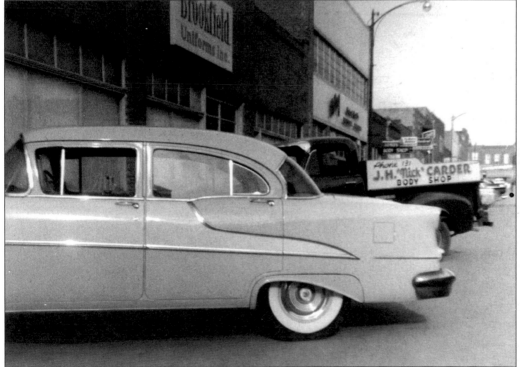

Carder's Body Shop was located along West Pine. Nearby was another body shop. "Nick" Carder stayed busy for several years working on cars. As soon as folks started driving, they were colliding with each other. There were also car dealerships downtown, until the 1970s when they all moved out to Business Route 50. Note the garment district signs. (Photo courtesy Bessie Carder.)

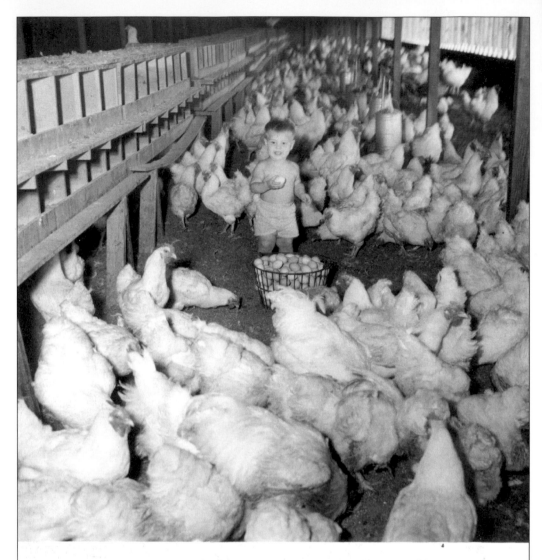

Even as late as the 1950s and 1960s, Warrensburg remained an agricultural center. There had always been poultry houses downtown. The Premier Hatchery had produced an impressive marketing campaign and sold all over the state. It was no surprise really, as almost everyone, in town and out, kept a few chickens. One producer John Iseminger published a calendar for their new farm. His wife, Joan McCluney Iseminger, had been brought up in a poultry house business. The child pictured is their son Rick. These are real Warrensburg chickens.

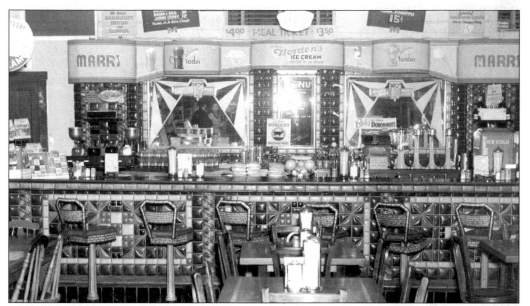

Marr's Drug Store was a popular hangout for students in town. The decor is clearly state-of-the-art for its day. Marr's Drug Store was owned by J. Kenneth Marr. The Marr family has been in the region, farming 1,000 acres and quarrying stone, among other things, for many years.

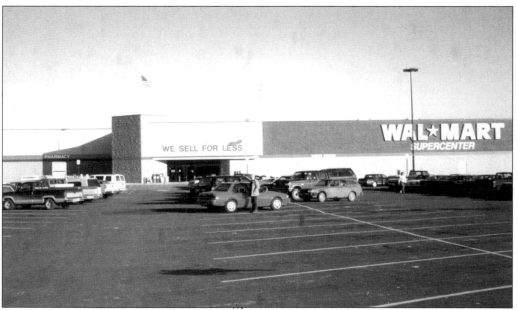

It would be ignoring the facts not to include the impact on the community that Wal-Mart symbolizes. Truth be told, this kind of movement has been happening since the first shift to the railroad. Now the 'burg has hit the highway. First there was the South Mall with McNeel's BILO, then Northpark with TG&Y. Economy Lumber, owned by the Myers Family, holds its own north of the highway, but the town continues to grow and evolv. (sic. evolv. is the name of a state-of-the-art telecommunications business locally owned, but new in town). Most new retail development of the town occurs near the intersection of Hwy 13 and U.S. 50 and reaches to the Wal-mart Supercenter just north.

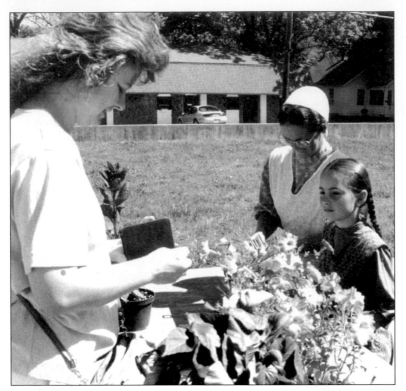

A farmer's market still operates every summer. Monday, Wednesday, and Saturday people have the opportunity to buy garden-fresh vegetables and fruits. Marketers sell organic beef and chickens, too. There are also gardeners who sell starts of perennial flowers, and now and then, there are pies for sale. This photo of a vendor once appeared in the *Daily Star-Journal*.

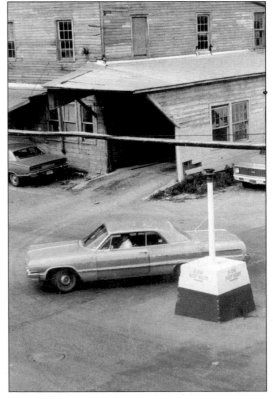

For many years, an obstacle that was used for U-turns stood at the intersection of West Pine Street and Washington. As the town's rather haphazard orientation to the railroad became obsolete, downtown customers were most interested in parking on Pine and Holden Streets. The Innes Mill stands in the background, an awesome structure of locally hewn wood, it was razed by 2000. Traffic today doesn't permit the turning block to be replaced, but Rex Smarr and Lynn Lederer Madeo are two folks who lament its passing.

Four
ENTERTAINMENT
AND THE ARTS

After the pioneers had established towns and businesses and "civilization," there was a little time for leisure activities. A cultural center from the beginning, Warrensburg held many opportunities for the adult in pursuit of happiness. As the town developed, entertainments were available for the whole family. Especially after the Normal School came to town, an influx of modern ideas assured that halls offering music, dance, and edification of all sorts would be a permanent feature of the village. Theaters, the Opera House, and Pertle Springs assured a running stream of traveling entertainers. Perhaps then, as now, the acts were mostly passing through from the east to the west, but the central location of the 'burg on a well-worn highway assures that quality entertainment will never be too far from home.

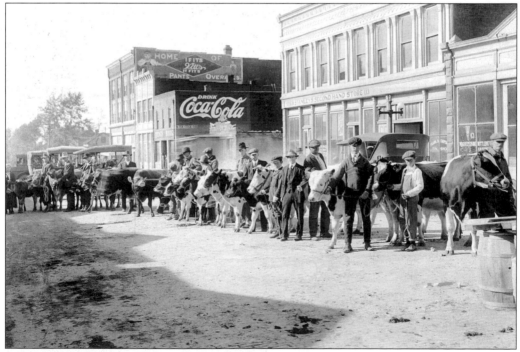

County fairs were an important part of life in a rural community. The local farmers came to display their agricultural prowess, all hoping to make their mark on the landscape as stellar providers of their particular commodity. Unlike today, most meat, dairy products, and other foods were locally produced with most families raising all they needed, often enough to share with their neighbors.

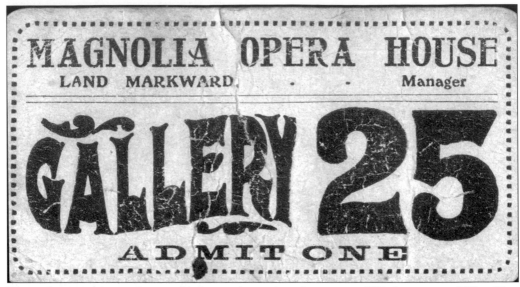

MAGNOLIA OPERA HOUSE
LAND MARKWARD. · - Manager

GALLERY 25

ADMIT ONE

This ticket represents a fine establishment located on the corner of Washington and West Pine at the turn of the century. Owned by Land Markward who had interest in the Magnolia milling operation, the Magnolia Opera House was once the site of entertainment of all sorts from distant parts. The hall remained busy until the advent of radio and movies. It also provided a town hall where meetings and public functions, like church programs and Howard School events, were held. Currently dubbed Fitter's Pub, the Millennium Club, Cocktails, and After Hours, the entertainment continues. (Photo courtesy Tom Christopher.)

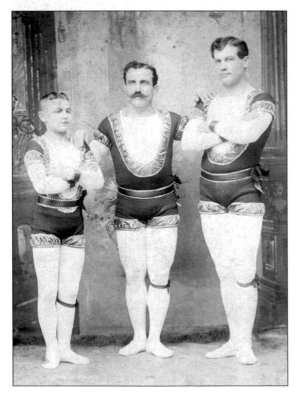

The Millette Brothers were just one of many acts that passed through the cultural center Warrensburg was becoming. They are known to have appeared at the Opera House.

A pioneer of ragtime, J.W. Boone was born in an army camp, perhaps the one northwest of the square in 1864. The son of a freed slave from Warrensburg, Rachel Boone, and a federal bugler/drummer, Boone was of mixed race. Though he lost his eyes to a brain fever before he reached his first year, this indomitable spirit first enchanted Warrensburg with a tin whistle band and then traveled the country playing piano concerts of original pieces and standards. John Lange was his manager, and he married one of the coloraturas who vocalized his music. The motto of his company was "Merit, Not Sympathy, Wins."

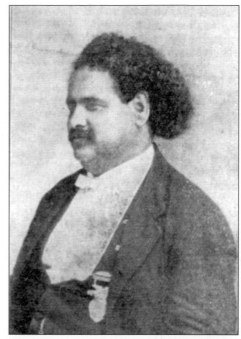

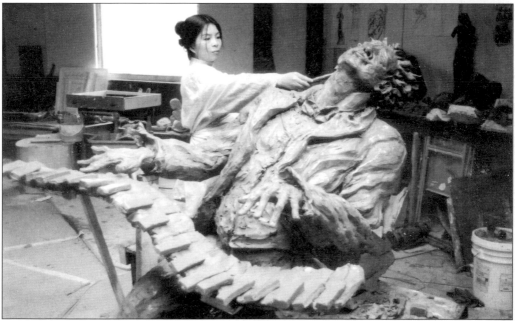

Sculptor Ai Giu Hopen of New York is bringing Boone to life for the Blind Boone Park Renovation Group. The park, which was created for black residents just before desegregation, had fallen into disuse after human rights were established in the 1960s. The group hopes to beautify the park with the statue and a gazebo for musical events. In addition to this statue in progress, and the most famous one (which will be discussed in Chapter Seven), Warrensburg has many sculptures. According to Main St., Inc., it has more than any town of its size. One is planned for a Children's Memorial and the campus has a number of permanent installations. (Photo courtesy Sandra Irle.)

A resort on the north end of town featured a horse-drawn trolley and healing waters. W.O. Davis, owner of the Davis Store, is enjoying a little recreation and perhaps he's abiding by all the posted rules. (Photo courtesy Nancy Anderson, a descendant who has worked for the City of Warrensburg for many years.)

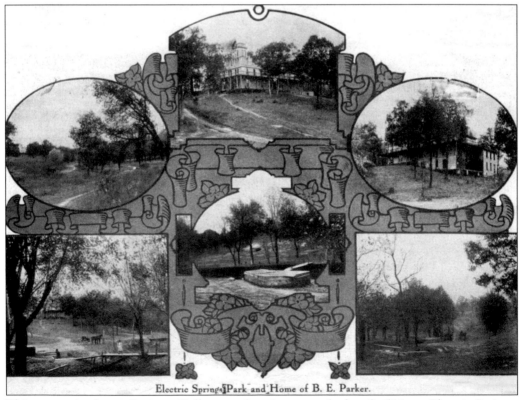

Electric Springs Park and Home of B. E. Parker.

This composite from a Business College catalog gives a rare look at facilities at Electric Springs. (Photo courtesy Tom Christopher.)

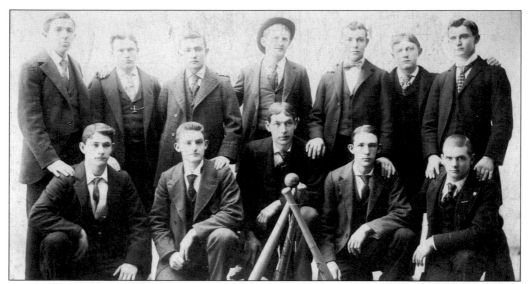

Lots of baseball teams have played in and around Warrensburg. These young men look like a force to be reckoned with. They include "Scrubby" Day, "Ike" Markward, "Liver" Hyatt, "Bulldog" Anderson, and "Buck" Russell. In 1939 Lou Fette, who lived most of his married life here, was a major league all-star, pitching 20 winning games, striking out Joe DiMaggio, and appearing on Wheaties boxes. Baseball continues to be a popular pursuit around town. Many leagues at all age levels play ball all summer. In the spring, on the southwest side, announcer Bill Turnage can be heard broadcasting games from the Tompkins Field, recently constructed in memory of a favorite coach.

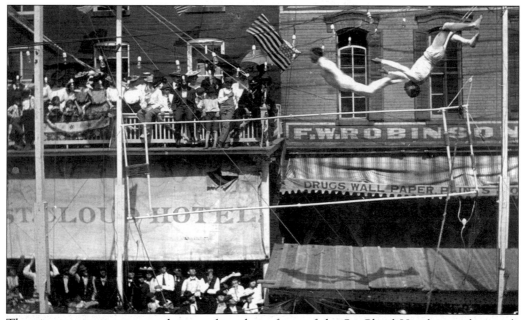

The circus came to town and set up directly in front of the St. Cloud Hotel, complete with animals, trapeze artists, and most likely, dancing ponies. Most who can now remember what came before think of this building as Woolworths Department Store. Trails Regional Library is now on this corner of Culton and Holden Streets.

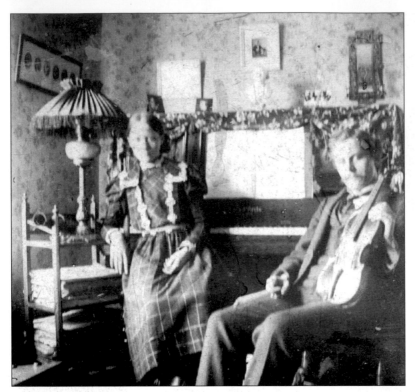

People also used to make their own fun. In fact, group singing may have been the most popular group activity in the years before radio and television. This picture from the Thornton family collection shows an interior scene of the home, a piano prominent. Susan Auchenback brought the piano from Union, Missouri, when she came here to educate children. At this time, you could buy a piano for under $40.

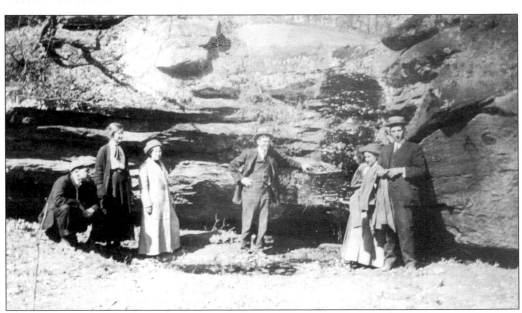

Cave Hollow was a popular spot for an outing and a lovers' destination. During the War Between the States, the Union Army had set up the Grover Post near this spot. By the 1960s, it was the town dump. Another community project of reclamation, Cave Hollow Park was developed in the 1980s. Again there are paths through the woods. Walkers ramble and children play at this lovely spot.

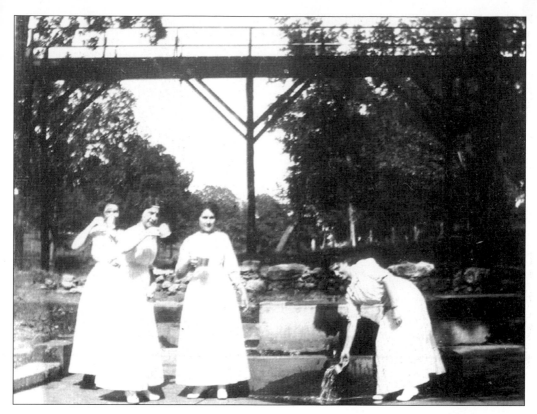

Come and drink from the springs. Pertle Springs was a fashionable resort at the end of the 19th century. Pertle (the name was changed from Purtle, as it looked prettier) featured 11 connecting lakes, a hotel—The Minnewawa—and an open air "Tabernacle" where several thousand people could hear a speaker before the age of amplification. This photo from the DAR files of the Heritage Library shows three of their members taking the waters. Behind them is a bridge, which connected the hotel to the auditorium. Below, a view west shows some of the lesser known structures.

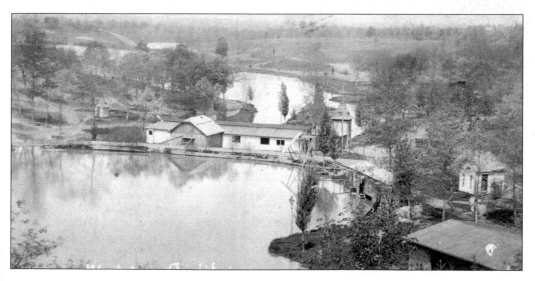

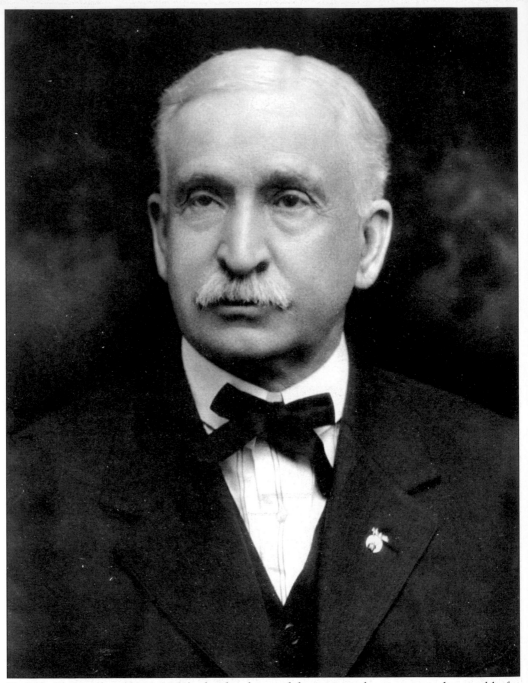

To J.H. Christopher (1884–1954), the developer of the springs, the city was indispensable for its water system, an electrical system, the first modern hotel laundry, a lovely downtown hotel, and a small rail system called the Dummy Line connecting it all. The "dummy," as it was known, was reportedly installed in order to transport a national convention of "Dunkards" from the depot out to the springs. The Missouri Pharmaceutical Association held several conventions there, too. At the time, you could buy a ticket at Grand Central Station in New York to Pertle Springs, though there were plenty of stops in between.

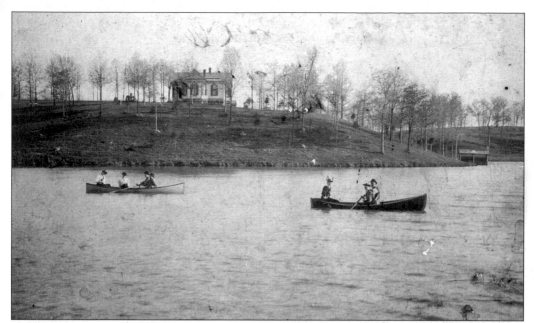

The Sams family helped Christopher get started. They built a house overlooking the tranquil Lake Cena. Though in the summer months, when up to 3000 people could camp there at one time, it was probably anything but tranquil. When the dummy train pulled up to the stop, visitors were greeted by a menagerie of animals and a concession stand.

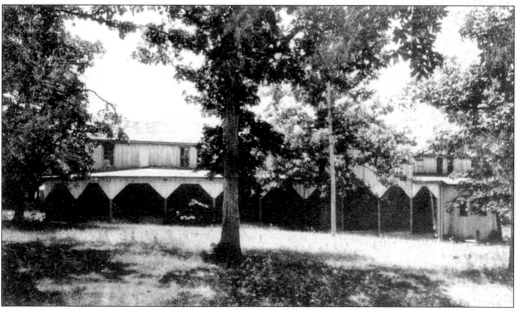

The Auditorium, or Tabernacle, as it was called during religious gatherings, was an immense structure under which 3000 people could hear a speaker in the days before power amplifiers. Here it is shown on a postcard. Many views of Pertle were captured on postcards, and some views exist in printed materials. Many conventions were held here: business conventions, war reunions, weddings, and all manner of gatherings. The springs was a busy place, and it had a professional photographer who would document a guest's special time on film.

J. Doug Morgan was the owner of a traveling show. The little person next to him must also have been a performer. Many entertainments were to be had at Pertle. There was a repertory theatre company producing as many as eight plays in a summer. Traveling shows and speakers passed through, including William J. Bryan in his 1893 campaign for free silver in Missouri. The entertainments were endless at the spa south of Warrensburg. The city limits didn't reach much past the college, which at that time comprised only the quadrangle. Today, at a club called the Set List, performers on their way to destinations anywhere may stop here and play a set. Silotree.com, named for an oddity off Hwy 50, is the clearing house for these wayfaring musicians.

The Cahills were the caretakers for the swimming pool at the springs. They are pictured here with their son. From left to right are Gene (holding Billy), Edgar, and Dora Cahill. Recognized by all who frequented the resort, they, too, became an institution.

The Chautauqua, originally a Sunday school teacher training institution in New York, had become, by 1922, a little more vaudeville. A tent show included speakers, vocalists, instrumental music, entertainments of all sorts. It didn't take long for the shows to get snazzier. The inside of the scheduled events features the program and scenes from the plays to be presented. Included were the Croatian Tamburica Orchestra, Anderson Ring Duo, Frank Allen (his lecture was "As a Man Thinks"), and a speech on Mexico. The supporters of the Chautauqua included almost every businessman in town. (Photo courtesy Tom Christopher.)

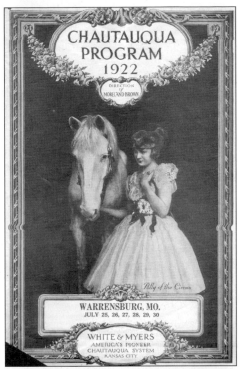

Dr. Jeff Yelton, archaeology professor at CMSU, is currently working with students to document locations of the several buildings and to find artifacts of the years that people used the springs as an outdoor playground. Owned today by the university, Pertle Springs is the site of a swimming pool, a golf course, and picnic grounds. The springhouse that was pictured earlier remained until the spring of 2002 when it was crushed by a tree in an ice storm. There is still an ever-flowing spring, though the sensitive palate of today finds the water sulphur-laden. (Photo by L.A. Irle.)

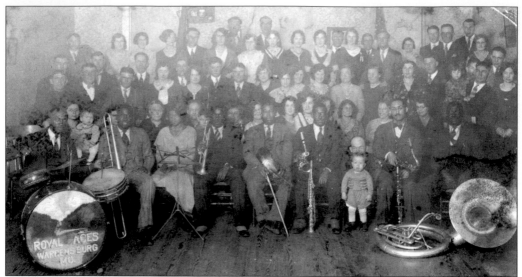

Bell Telephone paid a little over $6 rent to the Masons in 1898, presumably for office space. This is the first record of the telephone in Warrensburg. Other small companies soon took over the service. This picture of employees at a company party features the entertainment as well: The Royal Aces Band.

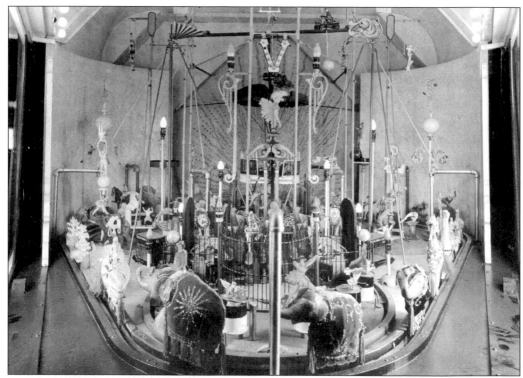

Inside a small tent, with Sam McCluney as the barker, this replica of the Ringling and Barnum Circus provided fascinating entertainment. Owned by Mr. Walt Hout, it was an attraction during McCluney's campaign for sheriff in 1944 and also as a traveling show. According to his daughter, he brought a lioness from the Kansas City Zoo to town as well. (Photo courtesy Joan Iseminger.)

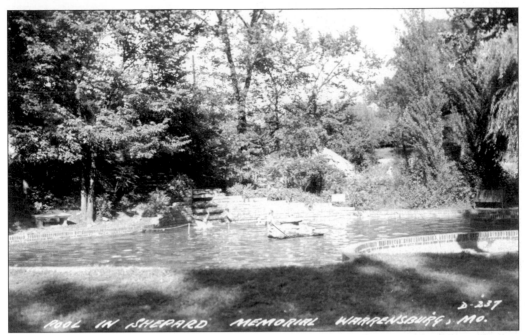

Shepard Park also had a pool at one time, a lovely pool in a natural setting. This postcard is one of few views known. This little park still features a concrete staircase, which connects the upper portion of the park to the lower.

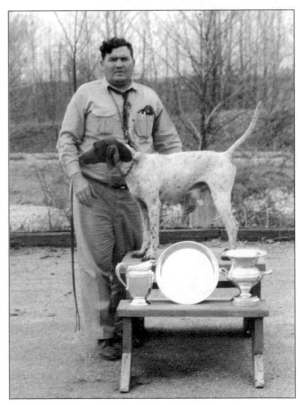

Hunting and fishing are other hobbies that connect us with an earlier day. Sam McCluney had a fine Pointer named Chasseur. He was a national amateur champion in field trials. On display are some of the trophies. (Photo courtesy Joan Iseminger.)

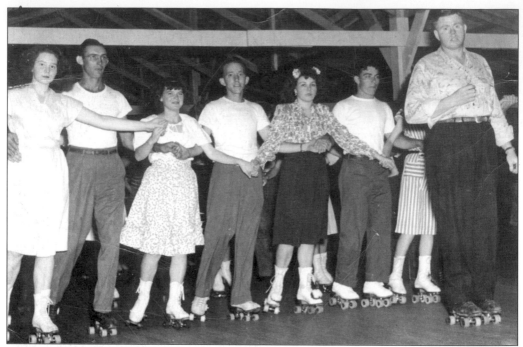

Another long-running source of entertainment in Warrensburg has been the skating rink. For many years owned by William Parsons and operated by his family, the rink was a nice place to go to get a little exercise and maybe meet someone with whom you could couple skate. "Couple skate... Couples only, please." Mrs. Parsons was often on the microphone. Pictured here from left to right are Wanda Heatherly, Dean Stump, Joan Warden, Leland Tresenriter, Pat Lamb, John Lamb, Jean Young, and William Price Parsons, leader. (Photo courtesy Ruthane Parsons Small.)

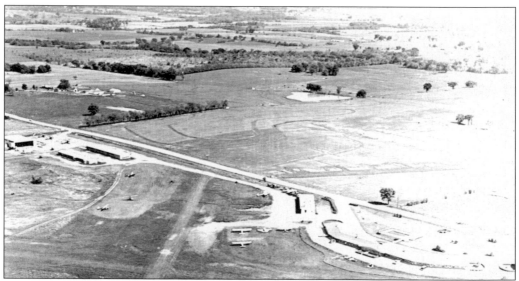

An asset to the town, which provides fun for its enthusiasts, is the small airfield originally known as "Skyhaven." This aerial shot of the hangars when they were new shows the area as it was. The airport, now called Max A. Swisher Airfield, is today part of Central Missouri State University. The aviation department has been well-attended for several years.

68

The Teehaus, run by Peggie Means, has been a downtown institution since 1969 and still serves coffees, teas, and affordable meals. The Teehaus has been a favorite hangout for the young resident and college crowd for years, at times offering live musical entertainment. A variety of shops have occupied the second floor. This establishment has operated longer than any other restaurant downtown. Talking to Peggie about her roots in Scotland and the affairs of the day has long been a treat for her customers.

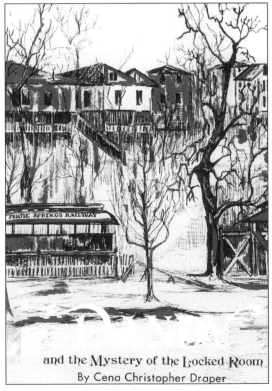

PERTLE SPRINGS RAILWAY

and the Mystery of the Locked Room
By Cena Christopher Draper

Cena Christopher Draper loved her grandfather, the Colonel, as J.H. was fondly called. In 1974 she wrote a book, *Dandy*, commemorating that time. This book jacket shows some of the features of the springs. In *Dandy* she writes that one day, 8,000 people were conveyed on the Pertle Springs railway "Dummy." In the days before air conditioning, city folk, even from as far away as Kansas City, were looking for a breath of air and a bit of shade that the springs provided. She was a speaker the Children's Literature Festival, an annual event which continues today, creating wonderful memories for the young students who attend. Cena wrote several books and plays. Many are largely based on her family life here in Warrensburg, so reading them is an interesting window to the past.

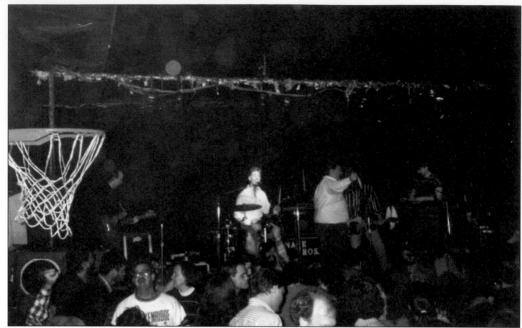

Bodie's has offered a venue for live music for over 25 years. This well-loved club has launched and/or promoted the careers of local dance bands such as Diamond Jim, The Nace Brothers, and Rampage. An institution now, the club opened by Mike Bodenhamer on February 10, 1976, is a favorite among local residents who still choose a dance floor for entertainment. This photo shows the Nace Brothers' band and some of their dancing fans. The Naces' father, Johnny, had some hits out of Nashville. (Photo courtesy Mike Bodenhamer.)

Dragonfly Extravaganza

Cave Hollow Park
Winter 1998

The Dragonfly Extravaganza, a venture begun by Matt Bird-Meyer, editor of the *Free Press*, has been staged at Pertle Springs, Shepard Park, and various other locations of historical proportions. This unpredictable event is a celebration of new writings, art, and music of the 'burg talented. This booklet contained the text of featured writers, published after the event in Cave Hollow Park. The founder has incorporated these eclectic presentations of art into local parks and geological features of the area.

Five

A TOWN OF TEACHERS

The west was populated largely by educated people, though frontier movies are correct in the assessment that many couldn't read and write. The early histories (of course, the histories recorded were paid for by the landed gentry) often mention college affiliations and law degrees. These were the people who financed the westward expansion. They started the newspapers and took pains to see that the populace was informed about politics and current events. Through the work of these erudite citizens, lobbying and politicking with leaders of the state, an education for the young Missourian was assured. Where would all these teachers come from? The teacher training school called Normal #2, now Central Missouri State University.

It is believed that this beautiful infant of the West family did not live long enough to attend school. Pioneer families of early Warrensburg were accustomed to losing children to childhood disease, a surfeit of persimmon seeds, or even doctors' errors. Little wonder that surviving children were adored and that their parents took great pains to see that they received a proper education.

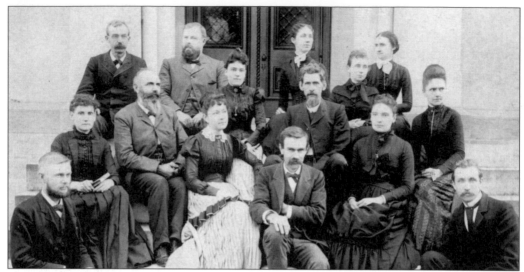

Though homeschooling (using the Bible and other classic books as texts) was the rule for the early pioneers, schools were soon formed in existing homes. A teacher rented space in the old courthouse before buildings for that specific purpose were erected. Early schools were usually log buildings near small settlements. One school specified that a log be left out of one side to serve as a window. One early teacher taught in a room in the old courthouse. N.B. Holden is given the distinction of being the first teacher and thus began the business of training teachers. These are a few of the first. Interestingly enough, homeschooling is still popular and not discouraged by the legislators.

Pictured here is the second oldest school for blacks in Missouri, and the first school of any kind built in Warrensburg. Howard, built in 1867, operated as an "elementary school—colored" until desegregation. The nearest "colored" high school until desegregation was in Sedalia. Howard's significance lies also in the cooperation of the Freedman's Bureau, the Missionary Society, and the local board of education. The building was listed on the National Historic Register in 2002. Ernest Collins graduated from Howard in 1941, but Herb Nelson and others later on were bussed to Sedalia for high school. Then the schools were integrated. (L.A. Irle.)

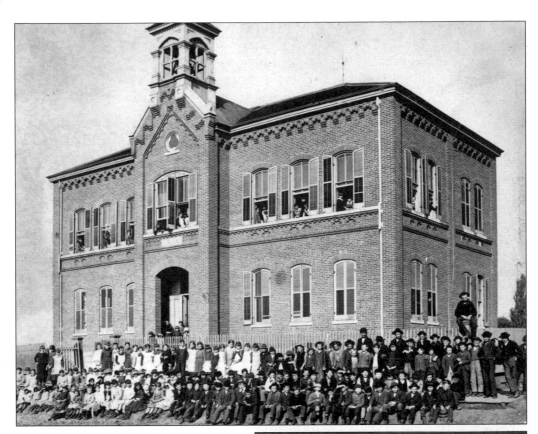

Reese, as it appeared in 1904, was already overflowing with students. In a panoramic view of Warrensburg, it towers over all in view but the courthouse.

William Crissey passed away April 1, 1924, just as his book *Warrensburg, Missouri: A History with Folklore* was being completed. He managed to include this mention of the Crissey School: "The fourth ward building was named Crissey, in honor of the writer who was a member of the school board twelve years." His lovely booklet, tied with a gold cord, is well worth a look.

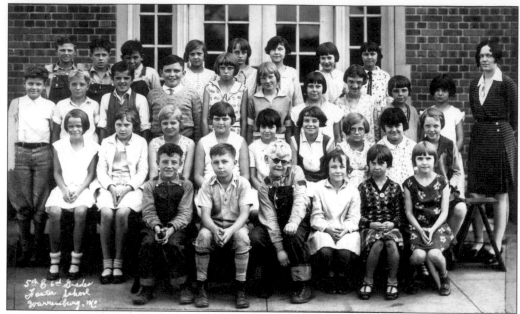

Foster School, built 1870, was named for M.U. Foster who was the county clerk and a strong promoter of the Normal. (Photo courtesy Flo Mullis.)

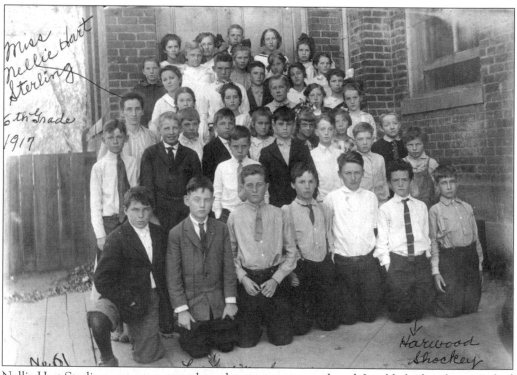

Nellie Hart Sterling was a career teacher who everyone remembered. It is likely that she never had teacher training, but she taught students until the early years of the 20th century. Here, a class of sixth graders poses in front of their school with Miss Sterling. In the 1990s, the building that had been the "new" high school and then the middle school became Sterling Elementary.

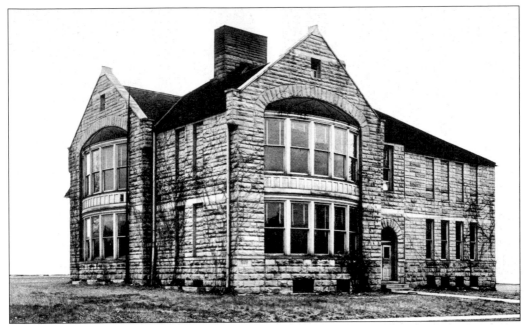

Warrensburg High School, as seen in the *Arrow*, WHS Yearbook, in 1915. Built in 1896, the school stands at the corner of Maguire and Gay. This school built on the site of Foster School (and now called Martin Warren Elementary) houses first, second, and third grade classes. It has served students at every level through the years. It became the junior high school when a new high school was built in the 1960s.

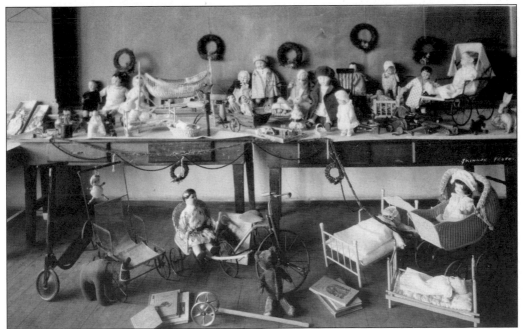

As early as 1929, PTAs were active. This Warrensburg High School PTA project was a toy repair workshop; the toys were to be sent to Children's Mercy Hospital in Kansas City. Another photo shows the before picture of the broken toys to be repaired.

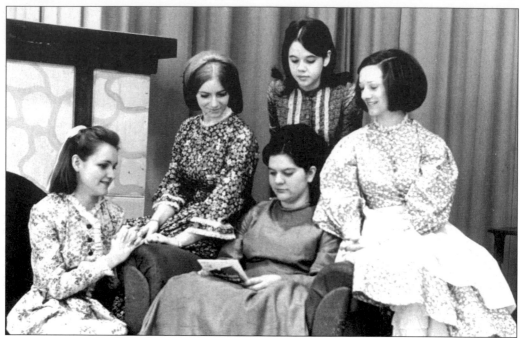

Mrs. Flo Mullis taught Speech and Drama at WHS, among other things, for many years. This is a production of *Little Women* under her direction with Ann Iseminger Williams, Cheryl Riddle, Janet Austen, Kathy Spicer, and Suzy McFerrin.

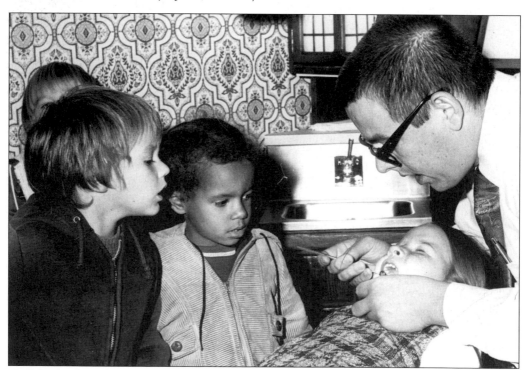

Health checkups have become common happenings in schools of today. Doctor Younger was doing a dental check, likely as a community service.

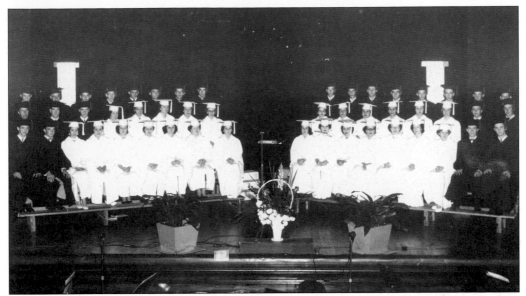

College High was a training school run by the college. There was quite a rivalry between the teams when Warrensburg had two high schools. The graduation ceremony for the class of 1953 was held on May 18 at 8 p.m. at Hendricks Hall. (Photo courtesy Joan Iseminger.)

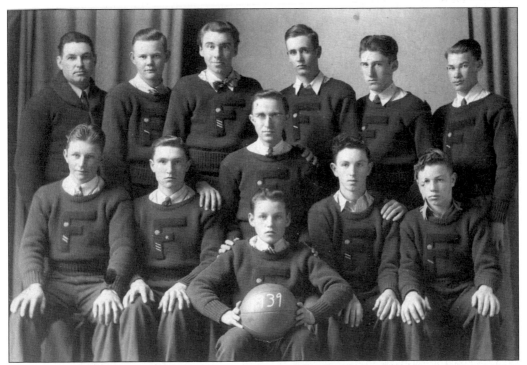

Farmer's School, northwest of town, is really part of the Centerview district, but Centerview deserves mention here. Once a thriving town, Centerview depended totally on the railroad. It was a shipping center, like Warrensburg, and some claim it was even bigger. Centerview has continued to operate a school, and Farmer's once served the northern reaches of the district. This basketball team includes several Bodenhamers. (Photo courtesy Mike Bodenhamer.)

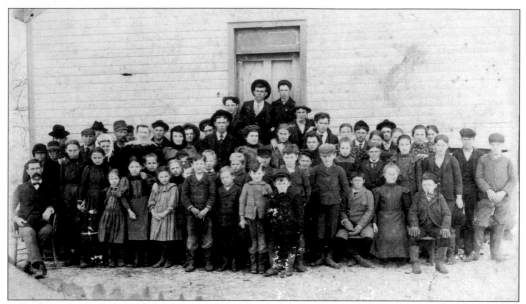

Walker School is typically rural. Students shown here had likely walked to school. Some early accounts say that the bells rung at 6 a.m. and again at 6 p.m. Education was not conducted at a breakneck pace then.

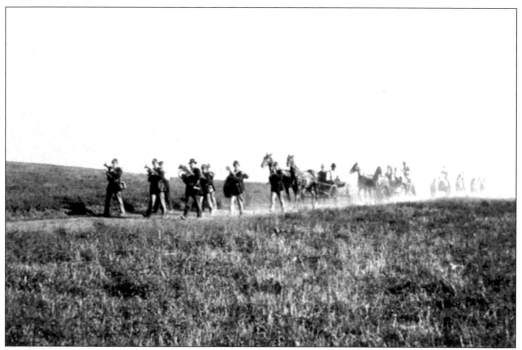

The Valley Band was one of the best of its kind in the state, or so it says on the back of this photo. Shown here marching across a dusty landscape, followed by horses, the band was on its way to neighboring Dawson School for a fair. Both were located southeast of town. Some of the musicians were John Fitterling; Fred, Chris, George, John, and Henry Greim; Bob Tuscosin, and Cap Brammert.

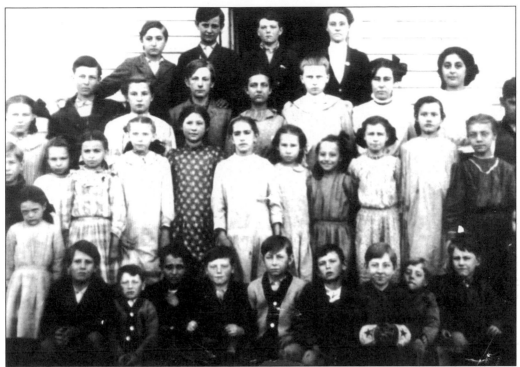

The Lone Star School was located in the Post Oak Township. Originally Mound School in the 1840s and Clearfork Church before 1900, the class roster in this undated photo includes the families of Warnock, Parmley, Chamberlain, Ward, Blackley, Laughman, Whitman, Blain, and Rhynerson.

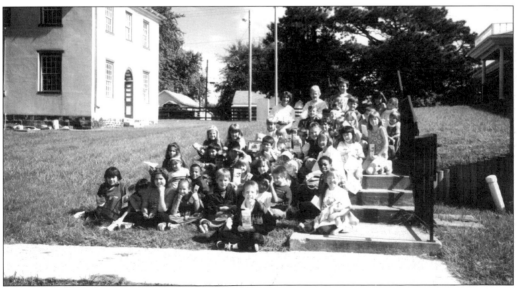

Martha Snider's class of first-graders enjoyed their visit at the JCHS Museums in 1998. Students from local halls of learning sometimes take a walking field trip across town to experience their historic roots. If only they could understand how far children used to walk in order to get an education.

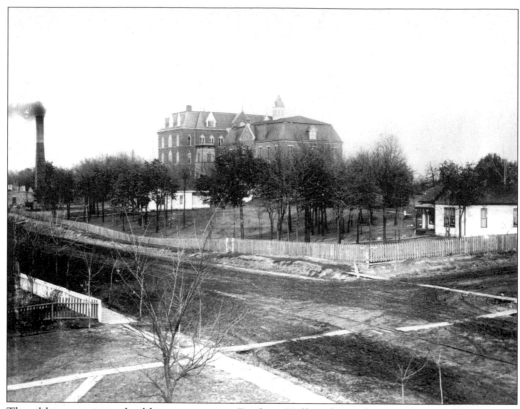

The oldest remaining building on campus, Dockery Hall, is shown here under construction. No living soul remembers this scene.

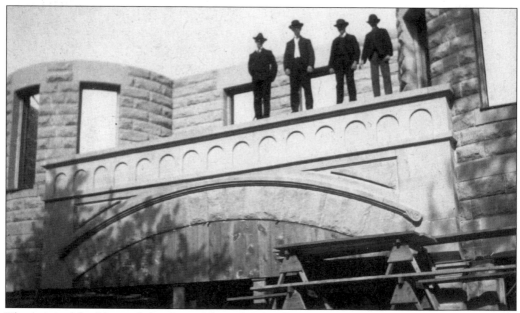

The original building of the State Normal School was built in 1887. The architecture was beautiful and this building symbolized the Normal until it burned in the 1920s.

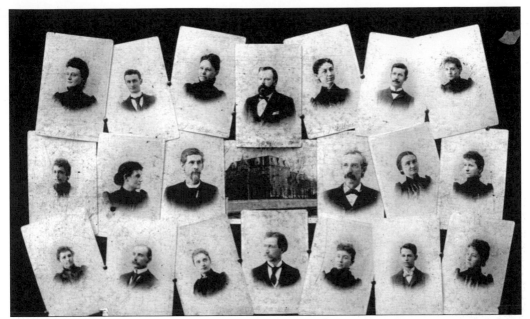

An unusual montage of individual photos done by Stone, the photographer, shows many of the earliest teachers at the training college.

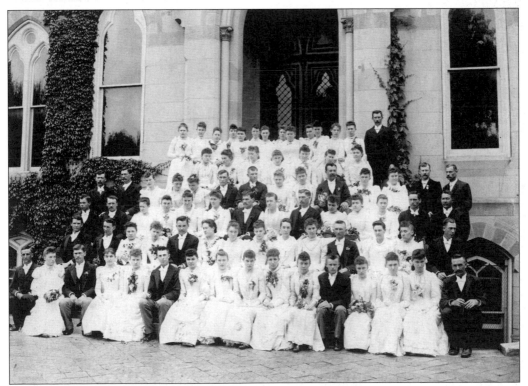

A graduating class posing in front of the original Normal building features students from the 1880s. It is one of the earliest images available and offers a close look at the architecture. (Photo courtesy Central Missouri State University Museum.)

These teachers went to Utah from Missouri to teach school. This group includes Mary Miller Smiser (seated in dark dress) who rode a small steam train out there in 1904. While she was out west, she was also able to survey the damage of the San Francisco Earthquake.

An alumni pageant features the graduates of several early years of the Normal.

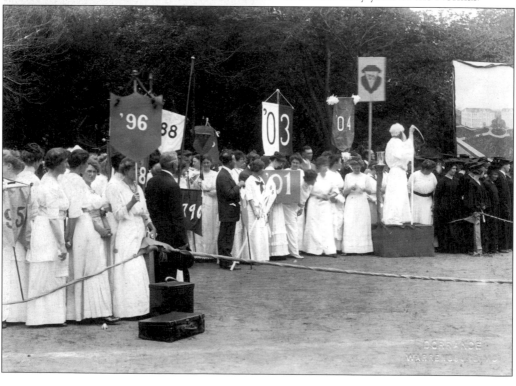

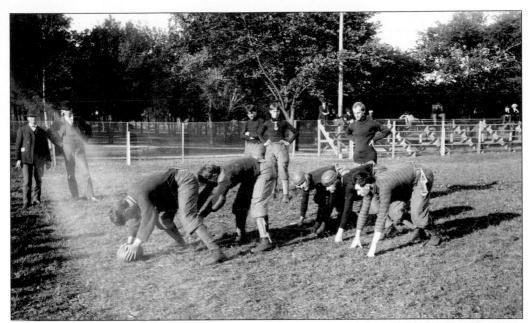

The football team practices under the direction of a beloved coach. This field appears to be in the days before the larger Vernon Kennedy Stadium was constructed. (Photo courtesy of Liz Schwensen.)

Stella Thomson Christopher was the Lower Queen of May, 1927, in the *Rhetor* yearbook. She later was librarian at Warrensburg High School. In 1953 she became a librarian at Central Missouri State College.

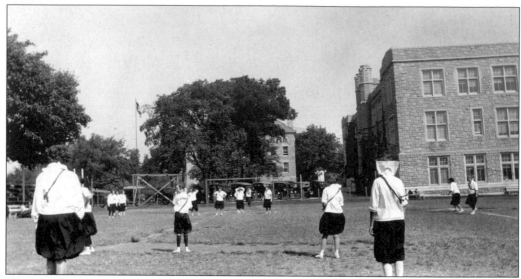

These athletic girls are sporting bloomers on an outdoor playing field. Though not all women were thrilled about the new fashion, many were ready for the change. Strong women professors in the athletics department included Lutie Long Smith, who lived to a ripe old age, traveling to the Far East in her 90s.

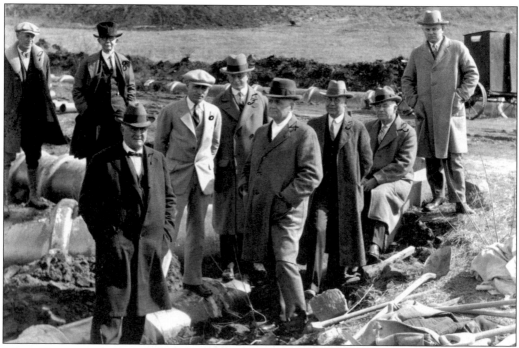

The college was constantly growing. After a fire in 1922, the campus was changed forever. New buildings continue to be constructed, and the campus continually grows. This committee (1927) features some well-known professors of early campus life, including the president at the time. From left to right are Prof. Packer, Prof. Morrow, Prof. Hoover, Dr. Schoefield (president of the board), Dr. Hendrix (president), Tad Reid (athletic director), Ben L. Sams, Prof. Scarborough, and C.L. Johnson (contractor).

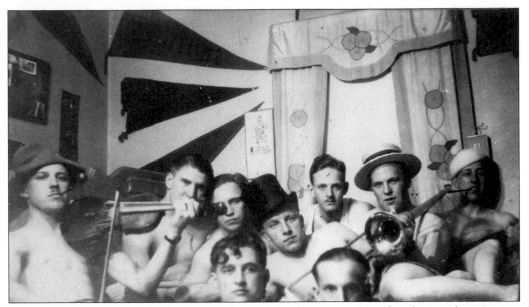

Known as the Mules' Heels, this group of young gentlemen may have lived up to their name.

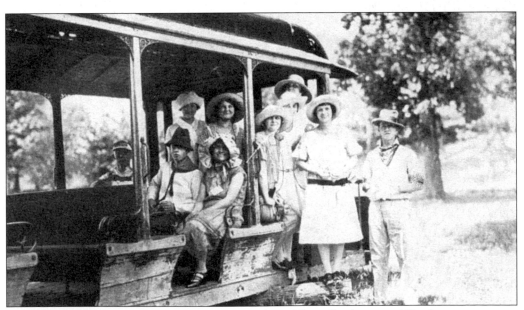

By 1926, the old Dummy cars were rusting on the sideline. Students used Pertle as a getaway from campus life. Several yearbooks feature group photos taken on the old cars.

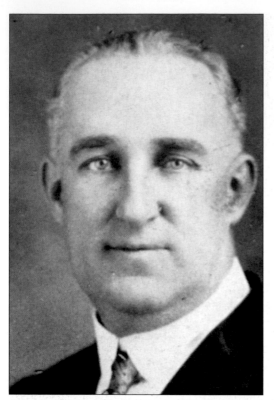

Essig Collection at Central's College of Music includes many instruments that have been rarely seen. The collection is housed in the hallways of the Utt Building, a legacy to all who visit those narrowed halls. This is Dr. Essig as he appeared in the faculty pages of the *Rhetor*.

From the yearbook comes this picture of the science department in the 1920s. A few birds are in the collection of the JCHS, but unfortunately the owls are not.

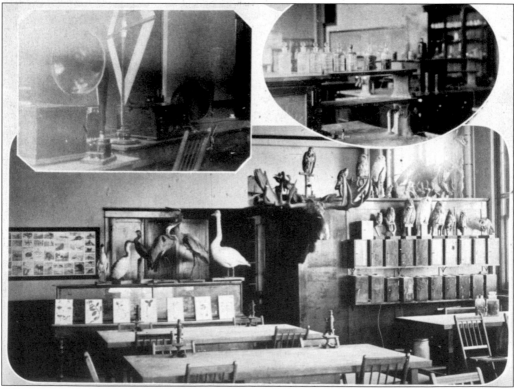

Dale Carnegie, author of *How to Win Friends and Influence People*, became a best-selling author who has assisted an inestimable number of people in overcoming fears of public speaking. His three-year involvement at the Normal in Warrensburg was surely influential in his career as a pioneer in the self-help seminar movement. An honorary degree was conferred later. This photo was taken at "Dale Carnegie Days," June 28, 1938. An institute that carries his name continues the work of this alum. (Photo courtesy CMSU Museum.)

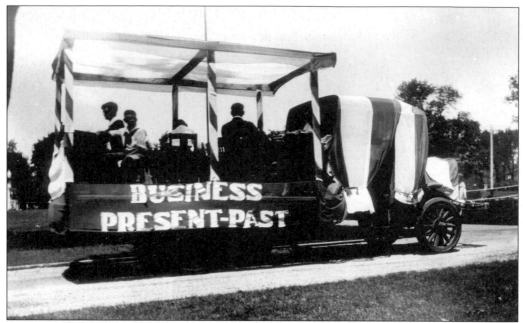

The Business School's float in a homecoming parade conveys their approach to the festivities.

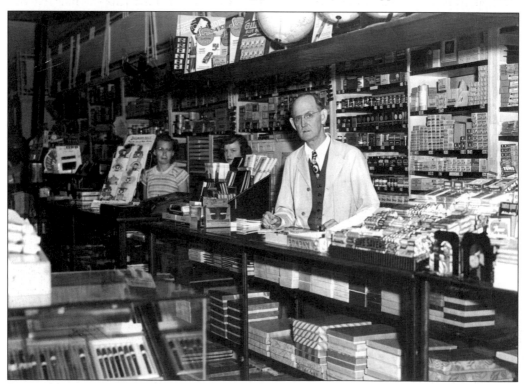

Pictured here is Mr. Kenneth Robinson, proprietor, and two young clerks in the College Store, which operated from 1927 to 1959 at 120 North Holden. This photo was provided by his daughter, Mrs. Sue Crouch, who studied and taught history in the schools of Warrensburg. The motto of Robinson's was "If it's used in college, we have it."

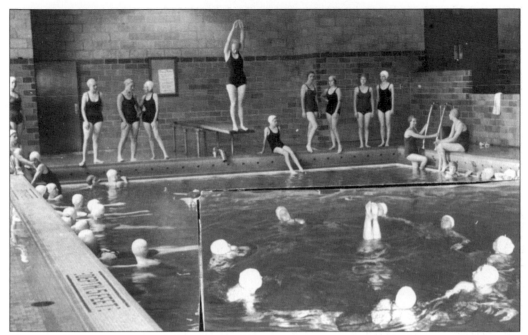

Garrison Gymnasium, one of the older buildings on campus, contained what was probably the first indoor pool in town. For a quite a long while, it was the only pool in town. Swimming classes were very popular and synchronized swimming was evidently taught at one time.

Memorial Chapel on campus as it appeared in the 1964 *Rhetor*. The Church of the Brethren, which had sold their church on the corner of Holden and Clark Streets to the college, held services in the Memorial Chapel under the pastoral care of Ethmer Erisman until their new building was completed. Their church became the campus museum for a time and small dramatic productions were also staged there.

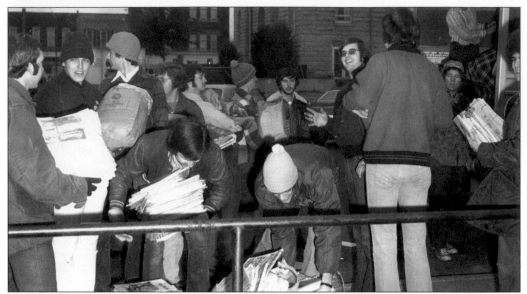

Community involvement has long been a focus of university life. Recycling became an attractive way to demonstrate a passion for saving the environment. This impetus has never stopped, as a group currently operates a once-a-month recycling collection program.

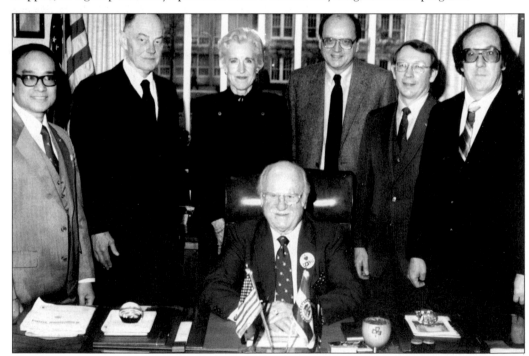

An altruistic soul, as well as the representative in the Missouri House for many years, James Kirkpatrick is pictured here with Dr. Lee, Leland Culp, Avis Tucker, Art McClure, Duane Sterling, and Baird Brock, all members of a committee that helped to create the position of Distinguished University Fellow. His friends, and a resourceful carpenter, made every attempt to recreate his Jefferson City office on campus, where he served out the rest of his days. His generosity made the building of the new library possible. (Photo courtesy *Daily Star-Journal*.)

Six

FIGHTING FOR FREEDOM

Missourians had a hard row to hoe during the Civil War. In 1861 an election for county clerk resulted in the upset of James McCown, who had held the office for some time. After the election and before a different crucial vote, a shootout between the new clerk, Unionist Marsh Foster, and McCown's son Frank resulted in Foster's death. Missouri, though adamantly trying to avoid it, was in a state of war, so the McCowns, secessionists, traveled south to join the army of Sterling Price. Surprised visitors to the Old Courthouse today can hardly believe that the Civil War affected anyone west of the Mississippi river. But, try as they might to remain neutral in the Union/Secessionist antagonism, Missouri was unable to keep the wolf at bay. While slaves were held by only 3 percent of the residents of Johnson County in the 1860 census (according to research from original documents at the JCHS by Dusty Poskocil in 2002), criminal acts of the neighboring red leg abolitionists from Kansas, in particular, forced individuals to take sides.

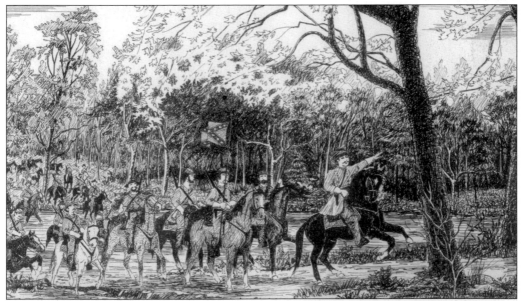

William C. Quantrill was a Confederate serving under Sterling Price, and he later became a guerrilla leader in the western border states. From hideouts along Blackwater Creek, Quantrill and his bushwhacker raiders attacked their enemies: Union troops and militia. This drawing depicts Quantrill assembling his troops for the retaliation against certain residents of Lawrence. According to oral tradition, the band bypassed burning the Old Courthouse on Main Street. Locals had erected a formidable stockade around the building to save it. While this tale is uncertain, the Old Courthouse remains one of very few public buildings of its age in the region.

BY-LAWS.

COL. GROVER POST

No. 78,

GRAND ARMY OF THE REPUBLIC.

DEPARTMENT OF MISSOURI.

ADOPTED JUNE 12TH, 1884.

ARTICLE I.

NAME.

SECTION 1. This encampment shall be known as designated in the charter thereof: "COL. GROVER POST, No. 78, GRAND ARMY OF THE REPUBLIC, DEPARTMENT OF MISSOURI."

ARTICLE II.

MEETINGS.

SECTION 1. The regular meetings of this Post shall be held in the City of Warrensburg

During the War of Rebellion, both the North and the South raised regiments in and around Warrensburg. It is rumored both sides even alternated use of the same parade grounds near Old Town for drilling practice. They perhaps had practice engagements, and, according to printed accounts, swapped officers. The Grover Post of the Grand Army of the Republic was later established to commemorate Colonel Grover who was killed in the action at Lexington.

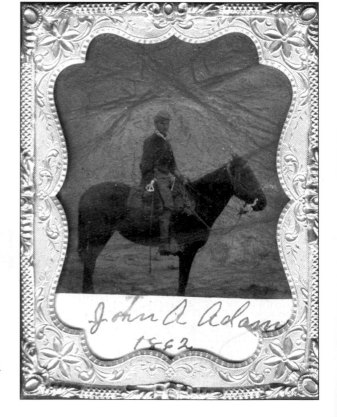

John A. Adams, pictured on his horse, served the Union army during the conflict. His home was pictured earlier and is now a Bed & Breakfast. (Photo courtesy Bill and Sandra Wayne.)

Born in 1831, the same year as Johnson County, Francis Marion Cockrell distinguished himself as the commander of "Cockrell's Brigade, C.S.A." After attending Chapel Hill College, north of Holden, he studied law, and during the Civil War met then-Senator (of the Confederacy) Vest, who served under him.

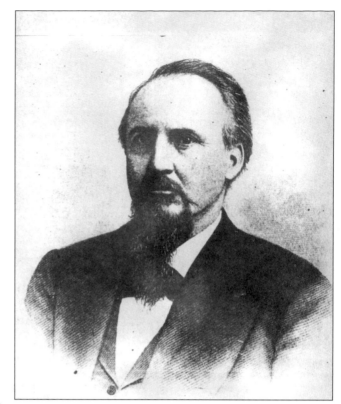

R.H. Wood, born in Johnson County in 1841, was one of Cockrell's men. He joined the Confederate army, served 3 years under J.O. Shelby and was in 30 engagements. He didn't receive a scratch. Leaving the army at the age of 23, he later served as a judge in the county court.

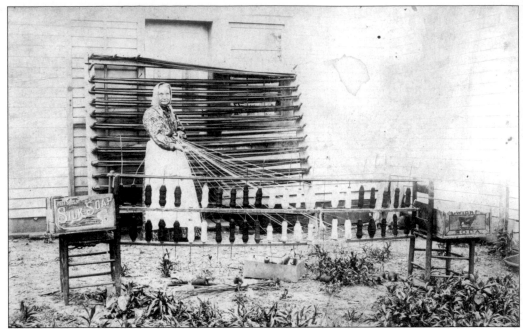

Sarah Cox (1840–1926) lived through these violent times and continued to make her way seven miles northeast of the city limits. Shown here among spindles of yarn, she clearly was resourceful and self-reliant, qualities indispensable for the pioneers. She is included here as a reminder that everyone in Missouri was affected by the "civil war." It is unsure whether Sarah was able to remain in her home during the war, but she lived out her life here after it was over. Her loom is in the museum at the Heritage Library.

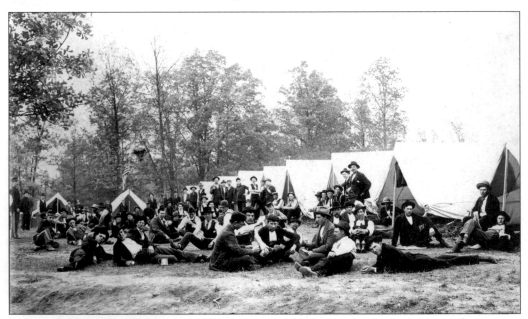

This photo of a Spanish-American War reunion at Pertle Springs shows the type of temporary housing that was commonly used at the Springs. The tents could be rented and it is believed that at least some of them were erected on wooden platforms by the campers.

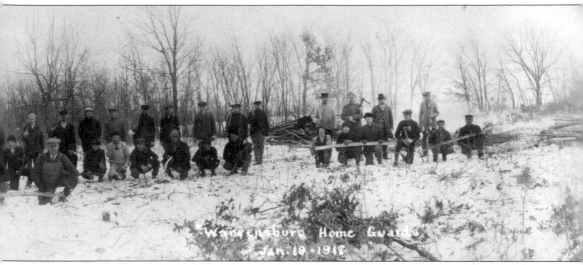

These young men, in between wars, were spending their tour of duty with axes and saws rather than guns. The Home Guard was the forerunner of the National Guard, instituted in 1917 by the Governor of Missouri.

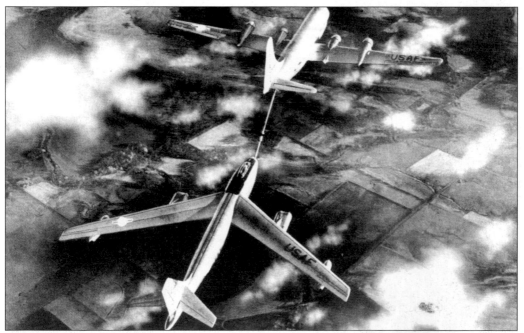

Sedalia Army Airfield, 10 miles east near Knob Noster, was a military installation originally activated on August 6, 1942, as the Sedalia Glider Base. A recording exists of Bob Hope boosting morale at the Glider Base. Some German POWs were held here for a time. During the massive demobilization in the mid-1940s, the base closed and most of the buildings were abandoned. In August 1951, however, it returned to life again and became a part of Strategic Air Command. SAC activated the 4224th Air Base Squadron. On December 3, 1955, Sedalia AFB became Whiteman AFB in honor of 2nd Lt. George A. Whiteman. Lieutenant Whiteman, a native of Sedalia, was one of the first American airmen killed in World War II when the Japanese attacked Pearl Harbor, Hawaii, on December 7, 1941.

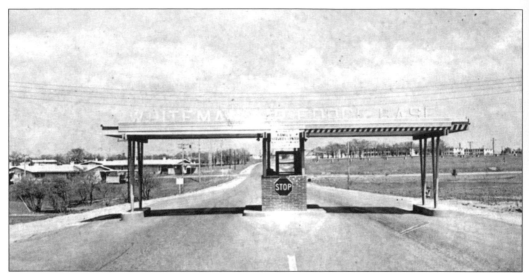

After the mission change in 1963, life at Whiteman remained relatively stable throughout the 1960s and 1970s. Still, there were programs to continually update and improve the base's weapons systems. Whiteman initially employed the Minuteman I weapons system until the mid-1960s, when a force modernization program converted the Minuteman I to the Minuteman II. Throughout the ICBM's tenure at Whiteman, it went through a variety of modifications to keep it at the forefront of America's defense. This is the West Gate of WAFB.

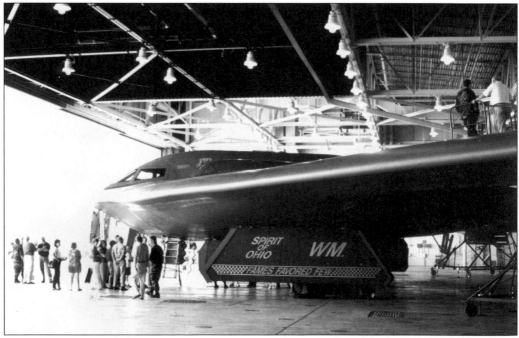

Throughout its history, the base has always been at the cutting edge of national defense. One day, at approximately 2 p.m., a dark jet bomber swooped from the sky and landed on the Whiteman runway. Amid much fanfare, the first operational B-2, the *Spirit of Missouri*, had arrived on December 17, 1993, and with the subsequent assignment of others, the future for the installation still holds promise. (Photo courtesy Mike Bodenhamer.)

Seven

"THE BEST FRIEND A MAN CAN HAVE"

One essential element of Warrensburg has yet to be mentioned. Not a man, but a fine beast—the dog known world-wide as "Old Drum"—holds the prize as the symbol of all that is good about Warrensburg. Veterans of the Civil War were finally moving back home. The consensus was that the court of law was a better place to decide controversies than the battlefield. No shortage of lawyers were practicing at the time, the listing of advertising attorneys in the local papers took up a good portion of the first column of page one. The trial may have been an opportunity for political grandstanding, but the outcome has outlived any of the participants and the lessons learned color the cooperation that exists in the community to this date. Community leaders from Warrensburg have served our city well, representing the people at all levels of government.

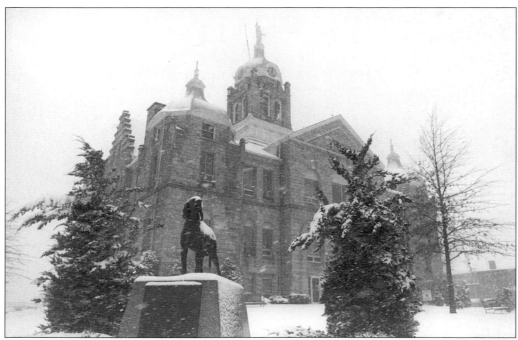

Roger Maserang, now State Historian at the Department of Natural Resources, took this photo. Though sometimes an object of ridicule (featured once in a *Mad* magazine map of the United States), the story of this noble dog, and the notable attorneys who represented his owner and his foe, is deeper than sometimes noted in the sound bytes.

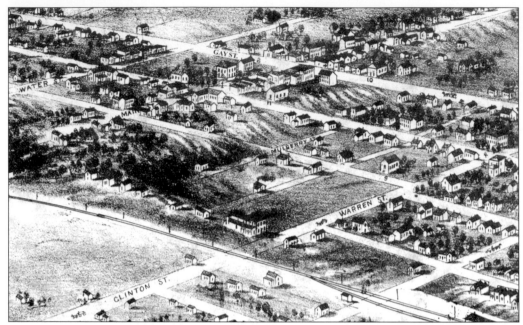

An aerial image done from a balloon in 1869, this print shows Warrensburg in the year 1869. A jail stands by the Old Courthouse. The railroad's influence is already visible as Old Town is about to lose the courthouse to "New Town" and the shining new frame structures already lining West Pine.

David Kesinger, who has participated in four reenactments of the Drum story, plays Hornsby this time. The family is calmly sitting on the porch when something startles the chickens. A gun is loaded—with corn—according to the depositions from the trial, and a shot is fired. (Photo by Sandra Wayne.)

Charles Burden was a pioneer and a cattleman. He made seven known trips to California. Charlie had a hunting dog, Drum, who was considered the best hunting dog in the county. Drum could track a man and was considered the best deer dog anyone had ever seen. Charlie found his dog dead of gunshot in Big Creek near Haymaker's Mill several miles west of Warrensburg. He confronted his neighbor and brother-in-law, Lon Hornsby, but the act was firmly denied. After a year of trials and errors, winning a paltry $25 and then losing an appeal, he hired Philips and Vest of Sedalia to represent him at the Old Courthouse.

It was under this tree that Drum was allegedly killed by a shotgun blast. Brother-in-law and neighbor of Burden, Leonidas Hornsby, son of Brinkley, an early settler, was trying to raise a champion flock of sheep. The Hornsbys were among the top ten wealthiest families in Johnson County in 1860. In 1869, they had lost 100 sheep to marauding dogs. Leonidas had been heard to swear that he would shoot the next dog that trespassed his land. When a shot was heard from the vicinity of the Hornsby farm, and Drum was found dead the next day, conclusions were quickly drawn. By the time of the jury trial in Warrensburg, he had hired the illustrious team of Crittenden and Cockrell to represent him. Hornsby had won an appeal and Burden's price of $200 was high. The winds were in his favor, and he had, he said, been protecting his livestock.

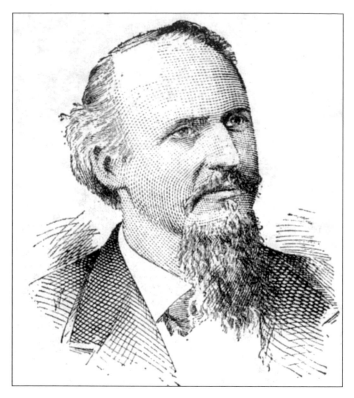

Previously mentioned, this native son had been serving as assistant to T.T. Crittenden. Cockrell, like other lawyers and clergy, had been handicapped after the war by the "iron clad oath." He had also lost use of one hand, the result of a war wound. Those ex-confederates who refused to swear they had never taken up arms against the Union/United States could not practice in their chosen fields. This oath was abolished by the U.S. Supreme Court in a case that originated in Missouri. Cockrell had an illustrious career in politics, serving Missouri as Senator in Washington from 1875 to 1904.

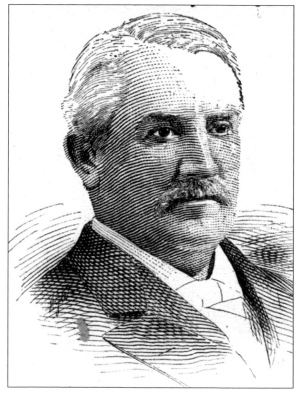

Thomas T. Crittenden had served the Union in the Civil War. Following the war, his office with Cockrell was located directly across the street from the courthouse on Main Street. "He became a leader in the liberal movement for equality of citizenship, peace, fraternity and good will, and boldly advanced these ideas in a brilliant canvass of a great part to the state." *Civil Government & History of Missouri*, Stephens Press, Columbia, Missouri, c. 1895. He owned property in and near Warrensburg and ran for congress, winning the election in 1872. From there he advanced to Governor of Missouri in 1880 and posted the reward for Jesse James, dead or alive.

John F. Philips of Pettis County had served as colonel in the Union cause, the Missouri State Militia. Along with Crittenden and Vest, he had attended Centre College in Kentucky before moving west to Missouri. He eventually served as a federal court judge, also distinguishing himself as a leader of the newly united States.

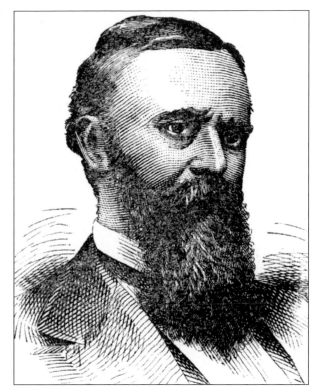

These four illustrations were printed in CG&H of Missouri.

George Graham Vest had furthered his education in law at Transylvania University and began practicing in Missouri by 1853. In 1861 he took the lead of the States Rights men. Later, he joined Price's army until elected to the provisional Congress of the Confederacy, at Richmond, Virginia, serving until '63. As the 1870 trial in Warrensburg progressed, he seemed uninvolved until he rose to give the great oration that would turn the tide to Burden's favor, *The Eulogy to the Dog*. The speech was chosen by William Safire in 1999 as the best example of an American speech of its type.

"Gentlemen of the Jury"

The best friend a man has in the world may turn against him and become his enemy. His son or daughter that he has reared with loving care may prove ungrateful. Those who are nearest and dearest to us, those whom we trust with our happiness and our good name, may become traitors to their faith. The money that a man has he may lose. It flies away from him, perhaps when he needs it most. A man's reputation may be sacrificed in a moment of ill-considered action. The people who are prone to fall on their knees to do us honor when success is with us, may be the first to throw the stone of malice when failure settles its cloud upon our heads.

The one absolutely unselfish friend that man can have in this selfish world, the one that never deserts him, the one that never proves ungrateful or treacherous is his dog. A man's dog stands by him in prosperity and in poverty, in health and in sickness. He will sleep on the cold ground where the wintry winds blow and the snow drives fiercely, if only he may be near his master's side. He will kiss the hand that has no food to offer; he will lick the wounds and sores that come in encounter with the roughness of the world. He guards the sleep of his pauper master as if he were a prince. When all other friends desert, he remains. When riches take wings, and reputation falls to pieces, he is as constant in his love as the sun in its journey through the heavens.

If fortune drives the master forth an outcast in the world, friendless and homeless, the faithful dog asks no higher privilege than that of accompanying him, to guard him against danger, to fight against his enemies. And when the last scene of all comes and death takes his master in its embrace and his body is laid away in the cold ground, no matter if all other friends pursue their way, there by the graveside will the noble dog be found, his head between his paws, his eyes sad, but open in alert watchfulness, faithful and true even in death."

Senator George Graham Vest,
Warrensburg, Missouri

plea for Old Drum

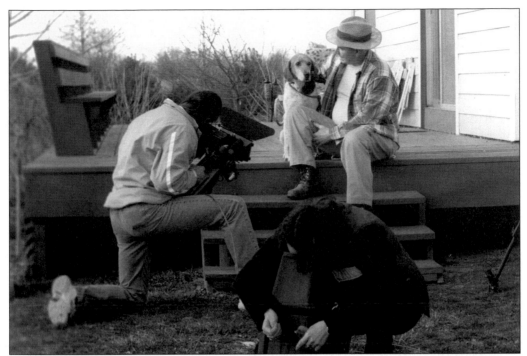

Several times the story of Drum has been filmed. An uproar was caused in the 1960s when *Death Valley Days* starring Ronald Reagan set our dog story in Kansas. *Animal Planet* has recently filmed a version set in the 1950s where Old Drum saves a child and lives on, attending his own trial. In 2001, the tale was told on *Kansas City Crossroads* on NBC 41 in Kansas City. This photo is from a German television documentary (from MME Productions) called *Dogsworld*, also filmed that year. The "dogumentary" has been translated into English as well. (Photo by Sue Sterling.)

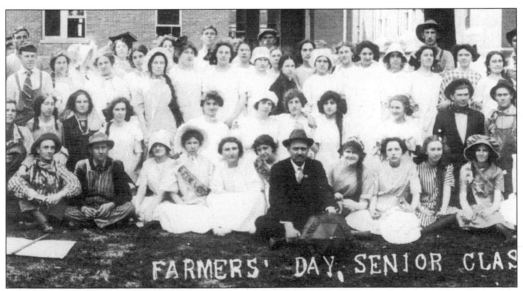

Black men got the vote, and by 1914, even Farmer's Day activities at the Normal had become political. Notice the sash in the front row which reads "Votes for Women".

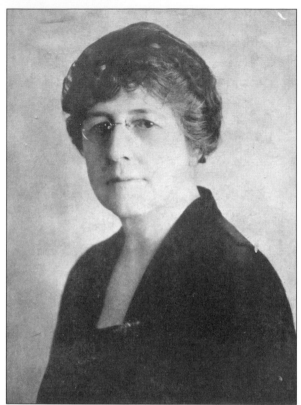

Kate Shockey Morrow, wife of Dr. Wm. Albert Morrow, was the first woman known to run for Secretary of State from Warrensburg. She lost the election, but this campaign poster from 1926 is testament to the fact that women, after getting the vote, were still ready for more influence in government.

Deleta Williams, first elected to the Office of Collector of Johnson County, has continued to represent Warrensburg in the house of representatives in Jefferson City to the extent of her term limit in 2002. Her committee appointments include Appropriations, Education and Public Safety, Budget, Education-Higher, Motor Vehicle and Traffic Regulations, Public Health and Critical Issues. Shown here from left to right are Williams, Sen. Harold Caskey, President Bill Clinton, and U.S. Representative Ike Skelton. (Photo courtesy Representative Deleta Williams.)

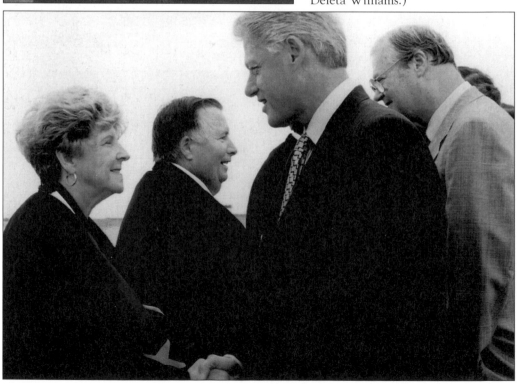

Eight
SOME TROUBLES

Though it's hard to imagine after hearing about all these fine upstanding citizens and builders of neighborhoods, there were those incidents as recorded in the newspapers and the county records that let us know that shenanigans were going on, similar to those in the movie westerns. Where history oft records legendary figures and deeds, the public docket and the press reveal a shadier side. Warrensburg is no different from other towns, and these, the oldest offenses, are least likely to cause hard feelings in the present.

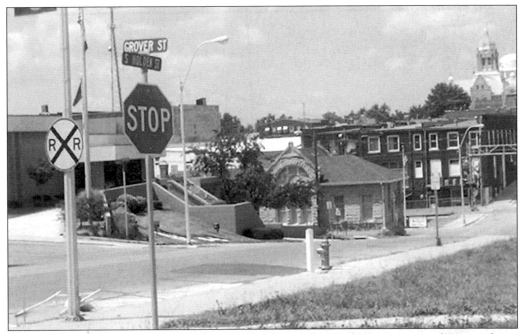

Though the Missouri Pacific railroad was stalled during the Civil War just east of Warrensburg, it was in the plat of 1857 when Col. Benjamin Grover had established his depot addition. There was quite an uproar when the depot was placed on the land of N.B. Holden "by mistake or otherwise," in the words of Crissey. Colonel Holden was assassinated at the door of his home in 1861. Colonel Grover was killed in action near Lexington during the war in a harrowing episode. In the 1880s, the Grover family lived on the site of Martin Warren's farm. From the intersection of Holden and Grover Streets, most of the downtown area is visible. The new city hall can be seen, as well as the depot. (Photo by L. Irle.)

S. K. HALL. N. B. KLAINE.

HALL & KLAINE,

EDITORS AND PROPRIETORS.

WARRENSBURG, MO.

SATURDAY, JULY 22, 1865.

Valuable and Important News!

Records of Johnson County Found!

They are in a Good State of Preservation!

Full Particulars of the Discovery!

As a part of the history of Johnson county, it is known that soon after the retreat from Lexington, in September, 1861, by the rebels under Sterling Price, a large portion of the county Records were abstracted from the Clerk's office, and their whereabouts, until Wednesday last, has ever since remained a profound mystery. Some believing that they had been taken with the rebel army to Texas, while others, knowing their great bulk and weight, together with the fact that transportation was not sufficiently ample at the time with the rebels to enable them, who had also hastened to town to toll the news, and finding his mission anticipated, hurried though to overtake the party, and proffer his services as guide to the secluded dell where the books were secreted. His services were gladly accepted, and found indispensable. At Hobson's farm our party left the main road and took a north west course across the open prairie country, traversed only with by-paths and neighborhood roads, difficult to follow except by the practiced eye, arriving at the point designated by the guide, precisely at one o'clock, P. M., Wednesday, July 20th, 1865.

The timber they now approached was composed of this densely growing post oak saplings from three to nine inches thick, and one would as soon think of worming through a gigantic steel hatchet as attempt to penetrate a thicket like this. Within which, a quarter of a mile from any visible path, they found the books secreted, and in a very good state of preservation, except slight damage of some loose papers from wood mice.

Lest some might be lead to surmise they were recently exhumed and left in this particular place, expressly to be found by some one, the Circuit Clerk assures us that the majority bore, every visible trace, such as wasp's nests attached to the covering, and the timbers on which they had been placed to provide against moisture, all rotted and deeply embedded in the ground, evidently showing it to have been one of ancient and long standing.

The large dry-goods box was found to contain the record and index books complete, consisting of more than 35 massive volumes, and the barrel was filled with packages of court cases and deeds left for record. As the mule-team could not be brought nearer than one quarter of a mile, the boys buckled too, with a will, and each volunteering to accept the commission of brevet horse for Johnson county, proceeded to shoulder the huge volumes and papers, when within an hour they had all safely deposited in the army wagon, and proceeding home without any further adventure. They arrived in town about five o'clock the same evening and safely deposited the long sought for documents in the Clerk's office, of will be allowed to return to their homes, not to be disturbed by United States authority, so long as they observe their parole and the laws in force where they reside.

Now let the first rebel that violates this contract bite the dust, and let every Union man see to it that the national faith shall not suffer at his hands.

For remember Truth, like the lost diamond, shines all the brighter out of the slough from which it is recovered. Lost Virtue even can again be achieved, beloved and cherished, but Honor once broken is lost forever; and that preacher or editor, who panders to vitiated senses—that seek to impair the sacred honor of the country—will, in the estimation of this community, sink to perdition so low that the hand of resurrection cannot reach him.

To Land Buyers and Emigrants.

All the County Records having been restored to us in good order, Emigrants need hesitate no longer about being able to secure good titles. There are thousands of acres of good lands in Johnson County for sale, with a soil for fruit and grape culture, excelled by none in the wide world.

The Record of Shame.

Now that the war for the Union has been fought to a successful termination, it is worth while to look back once in a while upon the course of the men in the North who opposed every measure taken by the Government to suppress the rebellion. Their influence was all thrown in favor of the enemies of the Government, and as they live among us, and will try to worm themselves into favor again by a fawning sycophancy towards the prevailing sentiment of the country, it is well to hold them up to the public scorn through the infamous record they left behind them. The following are a few precious extracts from Copperhead leaders and papers:

"History will relate that we (the North) manufactured the conflict, forced it to hot-bed precocity, and invited it."—Detroit Free Press, April 16th, 1865.

"The Democracy will yet teach Abe

Records discovered! Those McCowns had sent reinforcements after they fled the Foster killing. Several of their friends had agreed in 1862 or so to help remove the records to a location on Polly Hill's farm near Centerview. There the records were eventually stored in a barrel and kept safe in a thick woods until the war was over. Polly Hill was subpoenaed and lo and behold, while running some pigs on her back lots, she stumbled across the missing records. No charges were filed.

Thanks to Aunt Polly then, we have some idea of the crimes in Warrensburg from 1847 to 1852. The following are some of the offenses committed by the rowdier residents of Warrensburg when it truly was a frontier town. It appears on the opposite page that the fine is $10 for gambling, $100 for selling liquor to "Indians." The man with the gambling device may have been turned over to the State, rather than handling this matter on a county level.

No.	Att'y Names	Parties to Suit	Form of Action
1	Sawyer	The State of Missouri against Richard S Lomax	Gaming
2	Sawyer, Tillman & Sharp	The State of Missouri against Daniel Rentch	Selling Liquor to an Indian
3	Sawyer, Sharp	The State of Missouri against Thomas Kerr	Permitting gambling device in his house

Trial Docket Johnson Circuit Court

THE WORLDS TEMPLE OF HEALING

DR. HOOPINGARNER.

Dr. Hoopingarner's Temple of Magnetic Healing was founded in 1899 near the railroad station. Hoopingarner had previously set up shop in Knob Noster, and soon after, the Temple in Warrensburg had run its course. An article in the JCHS files documents a lovely reception held for the good doctor in the home of the mayor of Holden. The treatments were literally shocking and mildly pleasant. Go west young man, go west.

Pretending to be brothers, these two murderers befriended a German immigrant at their workplace in Kingsville. They convinced him to try his fortunes out west. One of them hopped a train with their victim, while the other purchased some hard lemonade. The travelers got as far east as Montserrat and started walking back for their missed stop in Warrensburg. On the walk home, their unfortunate victim was bashed in the head and robbed of all his money. The perpetrators began a reign of debauchery, which included a female traveling companion from a questionable establishment in the scandalous city of Sedalia. Caught in St. Louis, the fate of the criminals was not long debated. The double hanging of these two drew a large crowd. This woodcut was printed in the *Daily Standard*.

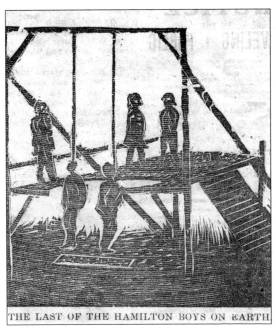

THE LAST OF THE HAMILTON BOYS ON EARTH

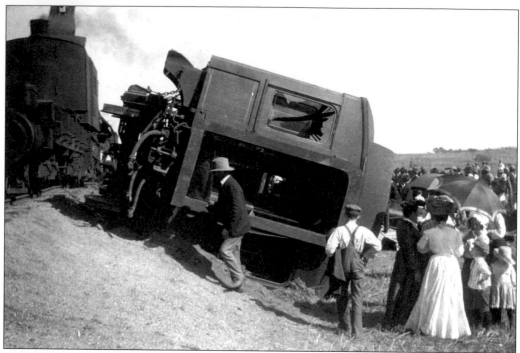

On the way to the World's Fair in St. Louis, an unfortunate misunderstanding caused the head-on collision of a passenger train going east and a freight train going west. Local photographers recorded the disaster. Many people were killed and a downtown building on the corner of Washington and West Pine served as a makeshift morgue. A book called *There Will be a Wreck* chronicles the event and the lives of the people it affected.

Maybe it's not really trouble, but hunting club members George Probst and Joe Bruch look like they're up to no good.

The Temperance Movement slowly began to clean up the area of saloons through a national organization in 1878— and then came Carrie's Campaign. A brewery burned and saloons were smashed as Carrie Nation of Holden, Missouri, made her way through Warrensburg. A partial list of the supporters of the Temperance Movement was printed as an appeal in the papers. Most were women, but some of the men joined in support. The women had to appeal to the men, because they had no vote. Reading rooms began to give alternatives to the drunken populace, as perceived by the supporters of the cause.

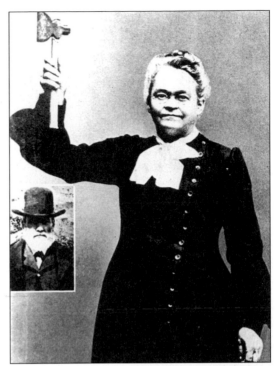

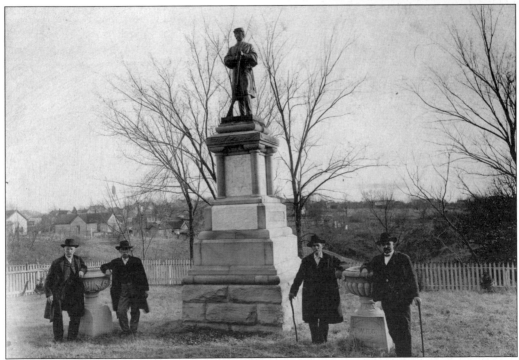

This memorial to Union Soldiers in the Civil War conflict has just been restored by the city of Warrensburg, which maintains the City Cemetery, now called Sunset Hills. The men pictured are identified as "Comrades... Al Drummond, J.W. Miller, Mr. Smith and F.X. Wagoner." The first person buried in this cemetery was John Miller Jr., only eight months old.

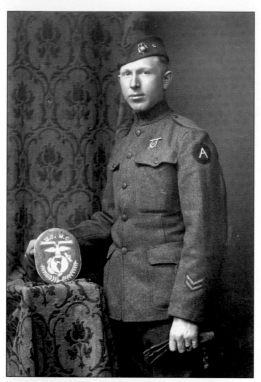

Willard Paul Gress served in the Marines during World War I. Shown here with the top of a mess kit on which he had etched the Marine symbol, he survived the war and had two daughters. Lucille Gress, his daughter, is a local historian who has written a book *An Informal History of the Black Families of the Warrensburg Missouri Area.*

L.L. DeCombes served the country in the Navy during World War I. Some of his informal photographs, taken at sea, are in the care of the historical society. The chickens apparently will not last long.

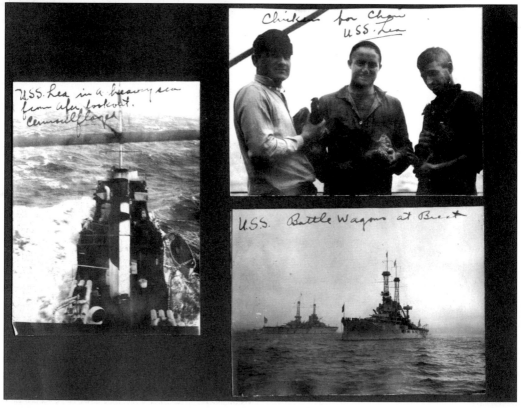

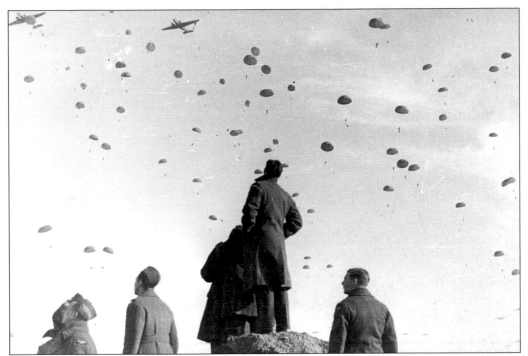

Oz Hawksley took this photo in Europe during World War II. An intelligence photographer traveling with the air corps, Oz was present at Arnhem, the offensive depicted in the movie *A Bridge Too Far*. Oz is well known statewide for his *Missouri Ozark Waterways* (in print since 1964), a guide to floating Missouri rivers.

This soldier, Charles Neff, served a tour of duty in World War II. Memorabilia from his service has been donated to the JCHS Museum.

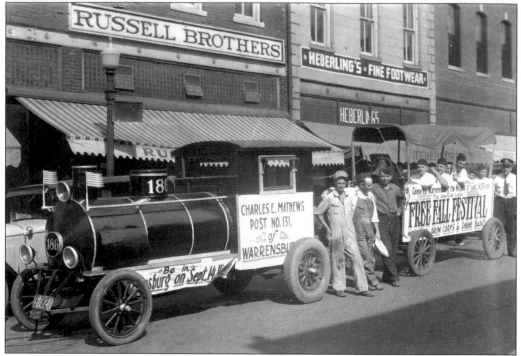

Members of the American Legion Post are pictured here, trying to rouse support for a festival. (Photo courtesy Connie Heatherly.)

The Estes Hotel, not long abandoned as an apartment house, was destroyed by fire in the last few years. This image captures a little of the architecture. Once the hub of Col. Christopher's thriving resort, we remember it now only in pictures. The dummy railroad line began at the Estes Hotel, and Rachel Boone, the musician's mother, worked there in the laundry before finding work with the Cockrell family. (Photo by Deb Gallman.)

Nine

JOHNSON COUNTY
HISTORICAL SOCIETY

Finally, tribute must be paid to the organization that has made this book possible through diligent preservation of the history, not only of Warrensburg, but of the entire county of Johnson.

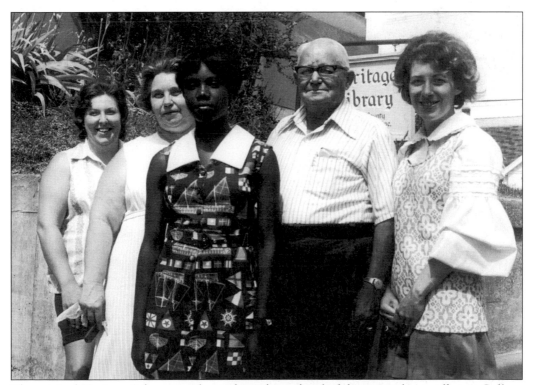

The original Heritage Library was located in a lower level of the original post office at College and East Pine. Mary Miller Smiser and company found many volunteers. When the Old Courthouse opened as a museum, a corps of dedicated individuals from many different organizations took turns giving tours and keeping the facility open every Saturday. That was in the good old days. The responsible party picked up the key at the fire station and returned it. More complicated in the days of vandalism and alarms, five volunteers work to keep the library open six days a week, from 1 to 4 p.m. Pictured here from left to right are Jan Stevens, Nadine Adams, Churphina Reid, Leonard Teater, and Myra Fish.

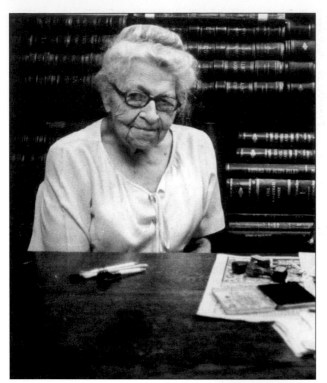

Mary Miller Smiser was an indomitable spirit and we are now in debt to her for being the champion of all things historical. As editor of the first *Rhetor*, in 1905, the more informal images of college life began to be recorded. She went on to become a national Vice President of the Daughters of 1812 and a member of many other organizations. The consensus is that the Old Courthouse would not have been saved if it were not for her determination. She attended the coronation of Queen Elizabeth, addressed the U.N. concerning UNESCO, rode a camel in Egypt, and was a centerpiece on a gypsy float in the Rose Bowl Parade. Her accomplishments would fill another volume.

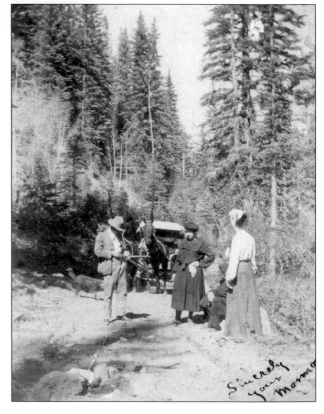

"This picture was taken after we had gone a little ways... During day I walked 9 miles and felt little the worse for wear. We were on top of mountain when sun set. My, but the view was grand. Came down [mountain] by moonlight, walked over half of way. Road was so steep Uncle Hi was afraid for us to ride. The moonlight is so bright you can easily see to read, and the bluest skies, and the most exquisite sunsets, coloring is grand and the climate is delightful." Written on back of photo by MMS, while teaching in Cedar City Utah, c. 1904.

A. Lee Smiser is astride one of his favorite horses, a champion show horse, Mont Ellen. He and Mary Miller met here and married, raising three children: Sam Smiser, Liz Schwensen, and Mildred Vyverberg. A. Lee was the first president of JCHS.

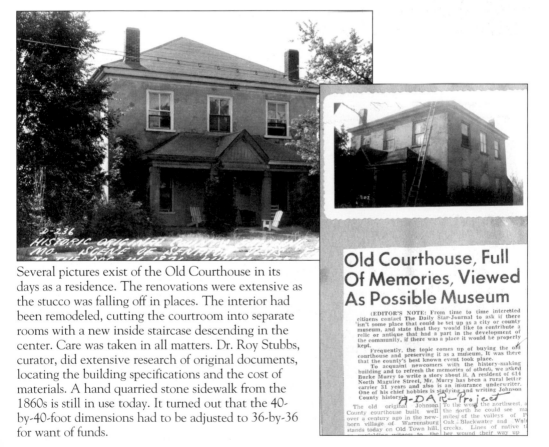

Several pictures exist of the Old Courthouse in its days as a residence. The renovations were extensive as the stucco was falling off in places. The interior had been remodeled, cutting the courtroom into separate rooms with a new inside staircase descending in the center. Care was taken in all matters. Dr. Roy Stubbs, curator, did extensive research of original documents, locating the building specifications and the cost of materials. A hand quarried stone sidewalk from the 1860s is still in use today. It turned out that the 40-by-40-foot dimensions had to be adjusted to 36-by-36 for want of funds.

Old Courthouse, Full Of Memories, Viewed As Possible Museum

(EDITOR'S NOTE: From time to time interested citizens contact The Daily Star-Journal to ask if there isn't some place that could be set up as a city or county museum, and state that they would like to contribute a relic or antique that had a part in the development of the community, if there was a place it would be properly kept.

Frequently, the topic comes up of buying the old courthouse and preserving it as a museum. It was there that the county's best known event took place.

To acquaint newcomers with the history-making building and to refresh the memories of others, we asked Burke Murry to write a story about it. A resident of 614 North Maguire Street, Mr. Murry has been a rural letter carrier 31 years and also is an insurance underwriter. One of his chief hobbies is studying and writing Johnson County history.)

The old original Johnson County courthouse built well over a century ago in the new-born village of Warrensburg stands today on Old Town hill, | To the west the northwest, the north he could see the miles of the valleys of Oak, Blackwater and Walnut creeks. Lines of native the her wound their way up

Pictured here is the interior of the Old Courthouse as it appeared during renovation.

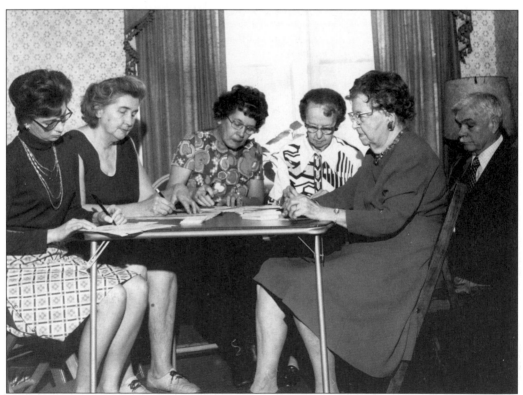

Mrs. Smiser had worked as Grave Location Chair for the Daughters of 1812 as early as the 1930s. This committee was recording Sunset Hill Cemetery information in 1974. Pictured here from left to right are: Mrs. Dale Williams, Mrs. Stanley Preston, Mrs. Mildred Adams, Mrs. Cyrus Jarman, Mrs. Gilkeson, and Dr. Sisson.

Sam Smiser left Warrensburg and moved to California after serving in World War II. He is shown here in a suit coat, but his usual working attire, and that of his employees, were overalls. The representatives of Smiser Shipping visited their clients in those particular garments, stepping out of one of a fleet of Mercedes automobiles on their beat. Sam kept teams of mules as well and he is driving some of them here.

A challenge was issued from Mrs. Smiser's son Sam. He would build a Heritage Library to house the work of the historical society if a matching amount could be raised for its maintenance in perpetuity. In representative style, the society members went from door to door, from business to business, in order raise the funds to give a permanent home to the collection.

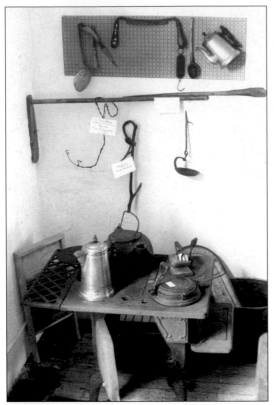

A sampling of the artifacts from the original pioneer museum, which was set up in a house on the corner of Main and Gay Streets. At that time, entering the museum was like walking into an actual frontier home from the earliest days of the settlement. By the early 1900s, these times were already considered the "good old days" by some.

Moved from Elm, Missouri, in 1996, this one-room school had been in use since 1911. In its first incarnation it had a second floor and was a subscription high school, by 1940 the top floor had been removed. The students from grades one through eight attended through the 1950s. The JCHS, with a donation from Robert Theiss in memory of his late wife, Jean Kesterson Theiss, was able to complete the restoration.

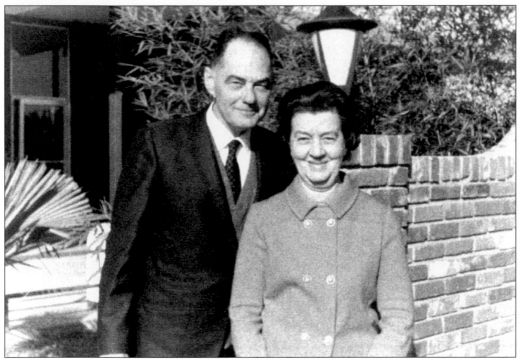

Leland Culp had a great impact on Warrensburg. He grew up the son of mill owner, Jesse Culp, to start his own company, Inland Chemical, in the same building where his father had operated the milling business. Fire extinguishers followed a swine remedy as mainstays of the company. Mr. Culp passed away, leaving his wife, Zinn, in the homeplace where the Smiser Alumni Center will soon stand on campus. She bequeathed his wealth to several community organizations.

Shown here under construction in 2001, the Culp Building is intended to house the larger pieces in the museum collection, particularly horse-drawn farm implements and larger items related to agriculture, as well as butter churns and spinning wheels. All four buildings on the JCHS grounds may be seen here. (Photo by L. Irle.)

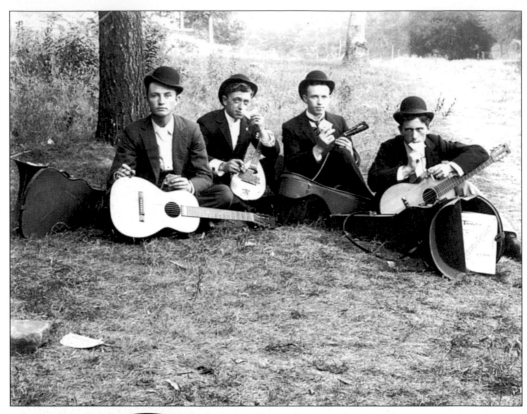

This Mandolin Club features Land Markward, manager of the Magnolia Opera House. Crissey says the Magnolia "was not a success as an Opera House." These young gentlemen look as if they are enjoying culture whether financial success is to be had or not.

Pictured are Mary Ellen and her dog.

A Mr. Grover and his dog—that's all that is known. Many of the photographs that have been donated to the historical society in the past are unmarked, making identification of the subjects nearly impossible. Which Mr. Grover? That is the question.

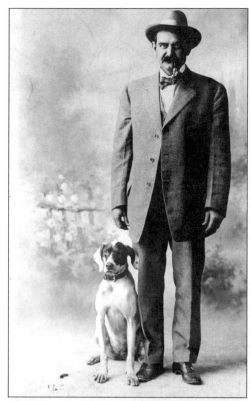

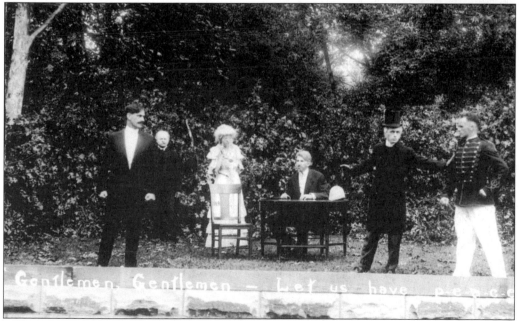

"Gentlemen, gentlemen, let us have peace." Fred B. House was in this play on the outdoor stage at the Normal, now a parking lot north of the Administration Building (Hendrix Hall). His character is off stage left, but the other actors play on. House was superintendent of schools for many years.

Shanklin Gilkeson was a well-known and loved member of the community. Shank and his family lived on an estate on Gay St. This appears to have been taken on a lazy summer afternoon.

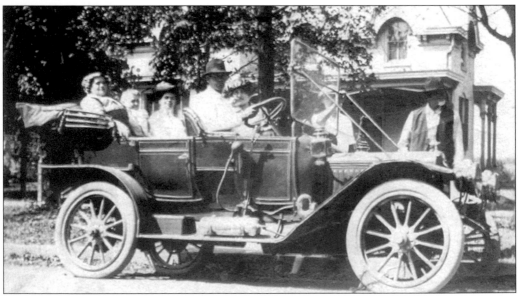

It has been said that this Maxwell caused quite a stir as Mr. Heberling drove out along the country roads by a school house. It being one of the earliest cars in the neighborhood, children would run to the windows and class was over until the dust settled. Heberlings ran an Ice Plant, a meat market and packing house, and Herberling Shoes, which at one time actually made the shoes that they sold to their satisfied customers. Henry Heberling rode a horse to surrounding farms to choose the best beef on the hoof. One time he was looking at a certain farmer's cattle pretty regularly. Soon, he chose the farmer's daughter as his wife. The car is shown here in front of the Heberling home, still standing, the brick painted red. (Photo courtesy Mary Heberling Bartles.)

A simple pleasure, just for the fun of it, a Tom Thumb wedding was entertainment. Though the children are not identified, they are adorable.

Goodall invented the rotary power mower. The first was a Briggs and Stratton engine fastened to a mower deck that was pushed with a straight wooden handle. This handle looked much like one on the old cylinder cutter, the kind that moved when pushed. Soon the machine became a more stable arrangement with two connected metal tubes intended for locomotion. Pushing was hard, so Max Swisher created a self-propelling attachment kit for the Goodall. Then he improved the concept even further, creating the original Swisher riding mower with a zero-turning radius. These red and white cutters have been a local favorite for years. They're fun to drive, too.

The whole populace came out in force to celebrate 100 years of the 'burg in 1955. The Brothers of the Brush pledged to grow beards, and the Sisters of the Swish made costumes for the entire family. A pageant was staged telling the history of the town and at the *Daily Star-Journal* the first photo history of Warrensburg was published, *Pedaling Through the Past*. As the sesquicentennial approaches, many remember the fun of that time. The museum collection contains many remnants of the all-out bash.

Francis Irle is pictured on the cover of a 1970 issue of *Today's Farmer*. His son, Roger Irle, was also featured in the magazine. They had just built a self-propelled, self-loading, square-bale hay loader out of an old truck. Inventors all, the farmers. Both men attended college at Columbia for a couple of years, but came home to work in the family business. These men exemplify the opinion that not all teachers are certified in the ivory towers. (Granted, Dockery Hall is a fine example of that architecture.)

Time marches on, buildings are razed, and new ones rise in their place. The edifices of town change and are recorded by photographers who haven't a moment to lose once a building is slated for demolition. This picture was taken at such a moment. The courthouse dome is visible through the empty window arch of the First Baptist Church, which stood until 2002 on the corner of Holden and Gay Streets. At that corner and throughout the downtown, an improvement project is once again transforming Warrensburg. (Photo by Mike Bodenhamer.)

The determination on this boy's face is meant to commemorate all the workers who built Warrensburg out of sandstone and soft brick on top of a little creek that used to run through the woods on what is Pine Street. Speaking of brick, it was Joe Wade who had a brick kiln near Post Oak Ford, who made the brick for the Old Courthouse. This tug o' war was sponsored by Parks and Recreation in 1978. Even when the work is done, we work as hard to have some fun.

In 1998, another milestone was celebrated: the 100th birthday of the courthouse on the square. Dr. Leslie Anders wrote a book about the history of the building. The dome itself was restored and the statue of Minerva took a little trip to the home of artist Jim Myers for a makeover. (Photo by Roger Maserang.)

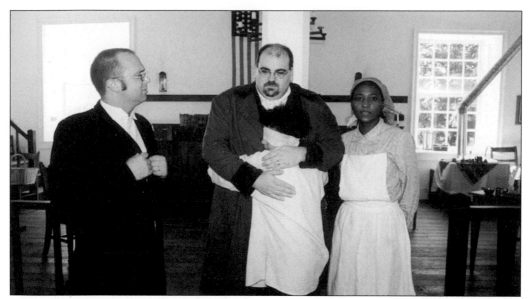

Shown here is the 2001 production of *Dog Gone... Again!!!* Both Cockrell and Crittenden were involved in the project of sending little Willie Boone to the School for the Blind in St. Louis. It should be noted that the woman who played Rachel Boone, MeShell Nelson, is the granddaughter of a woman who learned to play the piano from Blind Boone. According to the lore, Boone had played most every piano in town. MeShell has recently been seen on TV, interviewing the Harlem Globetrotters. Her sister Brenda was featured on the cover of the book *Voodoo Dreams*. (Photo by Sandra Wayne.)

The Dog Gone Truth was presented in 2002 with a cast of 33, the result of a 10-year collaboration with the JCHS, Lisa Irle, director and editor, and John S. Haug, playwright. An incredible chronicle of the people and events during the reconstruction period, the story has been reenacted many times. A group of CMSC students in the late '50s took a play to Branson to perform at Shepherd of the Hills theater. An orchestra piece has been written to be played behind the reading of the Eulogy. There is little chance of this story being kept in the dusty vaults of forgotten history. (Photo by Paula West.)

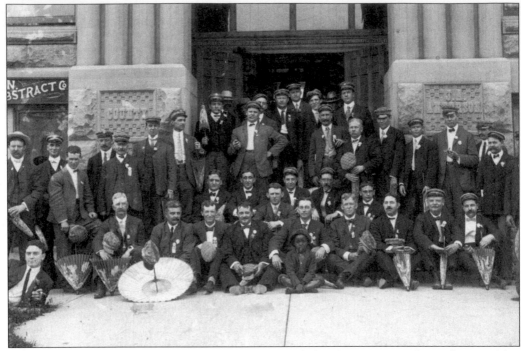

These Brother Elks in front of courthouse are pictured elsewhere in a parade south on Holden Street, their parasols unfurled. "And a little child shall lead them." (Isaiah 11:6) (Photo by L. Irle.)

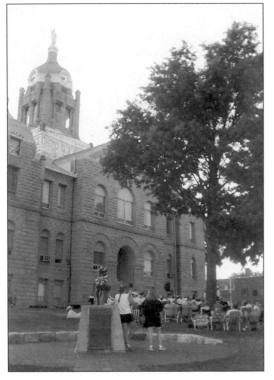

Life goes on in front of the courthouse and while much has changed, there are still band concerts and Fourth of July parades on the square. Warrensburg just seems to be where the magic happens. And so, for now, that's all she wrote.